GERMAN PAINTING
OF THE
SIXTEENTH CENTURY

GERMAN PAINTING
OF THE
SIXTEENTH CENTURY

Dürer and his Contemporaries

By

WERNER R. DEUSCH

With a Preface by

F. WINKLER
Director of the Department of Prints and Drawings, Staatl. Museen, Berlin

With 104 full-page plates in photogravure

HACKER ART BOOKS
New York
1973

First published in 1936 by A. Zwemmer, London
Reissued 1973 by
Hacker Art Books, Inc.
New York, New York 10019
Library of Congress Catalogue Card Number 73-79047
ISBN 0-87817-133-9

Printed in U.S.A. by
NOBLE OFFSET PRINTERS, INC.
New York, N.Y. 10003

PREFACE

The greatest period of German painting, of which a selection is presented here, was, like all other periods of great artistic achievement, a short one. It covers in fact a bare half century, and is dominated by the manifold genius of that greatest of all German artists, Albrecht Dürer. The very earliest works of this artist from Nuremberg proclaim the style that was to develop. With his death in 1528, in the same year as that of Matthias Gothart Nithart called Gruenewald, the decline sets in. Dürer's "Apocalypse" appeared in 1497, his "Große Passion" in 1498: beside these works, the products of a truly passionate spirit, everything produced till then seemed pale. Not one of the great artists among his contemporaries remained unaffected by the vitality, the emotional force and the grandeur of these compositions, which raised the popular art of the woodcut, then still primitive in technique, to a great and significant art form. And furthermore, though already on a higher artistic level, the engraver's art now gained through Dürer a more universal recognition.

The new spirit swept through the studios of Germany and after 1500 all are dominated by Dürer's influence, which soon penetrated even into the other countries of Europe. The first disciples must have been Lucas Cranach and Joerg Breu living in what is now Austria, and Matthias Gruenewald in the Middle Rhineland. Indeed of all the artists of his own age, only one, Hans Burgkmair, seems to have remained uninfluenced and true to the tradition of his native School of Augsburg.

It was the fame of Dürer that brought together a group of talented young artists in Nuremberg, among them Hans Baldung Grien, Hans Schaeuffelein and Hans von Kulmbach, who became his closest followers. By far the most gifted of these was Hans Baldung, a painter of many altarpieces, who carried Dürer's style with him to the Upper Rhineland. They worked too at woodcuts and Baldung in particular developed his master's ideas into a most personal expression. In fact his works with those of Cranach and the book illustrations of Hans Weiditz (also a pupil of Dürer) are the finest treasures of early German graphic art.

Indirectly, and probably through Cranach, Albrecht Altdorfer in Regensburg came to know the work of Dürer and was greatly influenced; he was to become the leader and the most accomplished of a number of minor masters of engraving, who until well into the middle of the century, continued to work in close connection with the master. Dürer's influence spread to every corner of Germany; his ideas were seized on avidly, but yet not slavishly imitated, by such powerful personalities as Gruenewald, whom today we consider as important as the master himself. Only those who investigate closely will perceive Dürer's influence: thus it is more on grounds of historical accuracy than as a necessary preliminary to the due appreciation of these various artists that the importance of Dürer is here emphasised. Indeed the work of each painter, that of the strange Gruenewald perhaps most of all, is so individual, and spiritually so rich, that it is best left to speak for itself.

The belief that the German creative instinct finds its most natural outlet in poetry and music, and that in the sphere of visual art it has never reached great heights, is further disproved by the achievements of Hans Holbein the Younger. He was brought up, uninfluenced by Dürer, in the tradition of his native School, studying under his father and Hans Burgkmair in Augsburg; but he it was who crowned Dürer's life-work with his "Totentanz" which brought the art of the woodcut to its ultimate perfection. The great son of an already great father he was possessed of that primitive forcefulness, that uncontrolled vigour of the truly creative temperament, which has so often threatened to break through the limitations imposed on all forms of art, even those imposed by the Church. Early in life however he learnt control, and his style took on that air of simplicity by which the effect of the greatest vitality is in the last resort obtained.

Dürer, too, strove hard, and created for himself a style which was both flexible and at the same time highly individual, though one which has borne its fruit. But Dürer was bound to the dying late Gothic conventions and particularly so in his woodcuts, which had an increasing influence on his painting. With Gruenewald, the greatness of whose achievement none surely will venture to deny, the late Gothic spirit reaches its final but most powerful expression. But whereas this singular artist left behind no pupils, Dürer had innumerable followers. One should not however overlook the fact that when the 19th century returned to Dürer for its inspiration it was as a direct result of the illumination shed by the classical purity of Holbein.

F. WINKLER

GERMAN PAINTING
OF THE
SIXTEENTH CENTURY

In contrast to plastic art which, in Germany, in the second half of the 15th century again reached one of its highest peaks, German painting about 1480 presents the sad aspect of being divided into a collection of decadent little schools. There are those of the Upper, Middle and Lower Rhine for example, the Swabian, Westphalian, Franconian and Bavarian each with its own traditions and receptive to no stimulus from without. Moreover the local studio conventions of form were growing increasingly rigid and dominant. The innovators of the first half of the century Conrad Witz and Multscher, whose achievements correspond roughly to those of Masaccio in Italy or of the brothers Van Eyck in the Netherlands, were followed, apart from the important figure of Pacher, by Herlin, Schuechlin, Zeitblom, Pleydenwurff and Wolgemut who met the demand for religious pictures in the accepted tradition by a large output of impersonal studio productions. The only common bond between this collection of more or less fertile local schools was a concentration on landscape.

Such a state was not peculiar to Germany although it was there most pronounced. In Italy, and in the Netherlands too, the innovators at the beginning of the century had been followed by a generation of artists whose work was to assimilate and popularise the new ideas of a few individuals. The tendency to return to Gothic forms obvious in such artists as Botticelli, Filippino Lippi or Pollaiuolo, their sentimentality

and the fineness of their line, is seen in Germany in the production of say The Master of the Hausbuch, The Master E. S. or Martin Schongauer. And in Germany, as in Italy, it was the generation of artists born in the last quarter of the 15th century who brought about the great revolution which changed the whole course of German art and opened up the path which has led even to the most recent developments. There was a sudden burst of creative effort, and all the fundamental qualities peculiar to German art asserted themselves in a most intense and strongly marked manner. The products of this period, covering roughly the years 1500 to 1530, represent the essential character of German art. With Albrecht Dürer born in 1471, Cranach in 1472, Burgkmair in 1473, Gruenewald a few years later, Altdorfer, Breu, Kulmbach, Schaffner and Ratgeb in 1480, Baldung-Grien and Niklaus Manuel in 1484, this first generation of artists was born in a remarkably short space of time. They it was who evolved and developed the new forms and ideas which were finally brought to perfection by the painters born at the turn of the century — Hans Holbein the Younger in 1497, Amberger and Pencz about 1500, Aldegrever and Barthel Beham in 1502.

Each of these men added something to the development of German art, which suddenly assumed a national character and at once took its place in the front rank beside Italian art. It thus became of European significance. Its influence radiated not only to the North and to the East, to the shores of the Baltic and to the Netherlands, but was felt too in Italy, in France and in England. The local schools became increasingly less powerful in the face of the general uniformity of expression characteristic of this period of spiritual upheaval.

When Dürer at the age of thirteen first took up his pencil and traced that, albeit somewhat angular, image of himself, which is now in the Albertina, he produced the first self portrait in the history of European art. But more than that his act was symbolic for the future of German

6

art. Although brought up in the atmosphere of rigid convention in Nuremberg, in the studio of that fine craftsman Michael Wolgemut, bound by the traditions of his guild to an almost fixed gamut of religious subjects, there gradually began to appear in this young man's work traces of certain of the most important elements of Nordic art. That awareness of his own form, that mood of profound introspection, that analysis of his deepest emotions, the general self-consciousness in fact, which is expressed in this youthful record is an essentially German quality. And just as the idea of a mere self-portrait would never have occurred to an Italian artist at that time, so he would not have thought of filling in the surrounding space, the scaffolding on which the whole composition depends, with a landscape. Yet next to portraiture, landscape was to become the chief subject of German art in the age of Dürer.

The Italian artist has no interest in the individual as such, nor in the appearance of life around him: nor indeed is he concerned with the relation of the individual to Nature, the intellectal conception of which as a unity dictates too strongly its limitations. Instead he is preoccupied with the relation of the individual to the cosmos, to the prevailing ecclesiastical or mundane conceptions of the universe. Dürer and Cranach, on the other hand, in their portraits, proceed from a psychological comprehension of their subject to an idealisation of humanity, a characteristic which brings them into line with the main nordic tradition of portraiture as best exemplified in the figures on the front of Naumburg cathedral, in the work of Rembrandt or in the pictures of Runge. Starting from a fragment the nordic artist evolves the most direct and powerful expression of his understanding of Nature as a whole. The most insignificant of objects inspire him. Thus Dürer's Netherlands sketch-book is full of studies of the most extraordinary natural objects such as animals' horns, birds' feathers, mussels, snail-shells and fishes' fins, each recorded with an almost childlike interest

7

in an accurate rendering of their real nature. In the same way the Dutch painters of the 17th century tried with renewed zest to wring from Nature its dearest secret, that of the real nature of those luscious bunches of fruit and flowers.

There is a similar difference between the German and Italian conception of landscape. In the artificial, formalised, scenic landscapes of the Romanesque artists all kinds of creatures taken straight from the world of classical mythology are able to continue their existence. But the German artists of the 15th century, although inspired by a symbolic or religious subject, as in the many pictures of "The Madonna in a garden", express through the surrounding landscape their boundless joy in the wealth of individuality in Nature. Again and again their literal transcription of Nature breaks through the strict canons of form. With their powers of imagination and their love of Nature they free these mountains, valleys and woods from the rigidity of convention, and invest them anew with life. Their vitalising force spreads through their whole world liberating the most insignificant of creatures and human beings alike. In Dürer's landscapes, seen at their best in his marvellous series of watercolours (the first examples of landscape painted for its own sake), and in the backgrounds of his various altarpieces, we are confronted with not only an expression of the development of his own personality, but indeed of that of his own epoch. His earlier landscapes express his pleasure of the world seen objectively: the sensuous thrill of natural colours is subservient to the plastic delineation of form. The contours of the landscape and its detail are noted with the utmost precision; the scene is not conceived as a whole but rather as a series of details. His later landscapes on the other hand, as in the "Adoration of the Trinity" for example, are inspired by a feeling of the unity within the vast organisation of the cosmos, where space prevails over matter. By purely pictorial means, that is to say by the suppression of details and the interrelation of

forms, he reveals himself as a painter, as a visionary almost, with power to portray the infinity of space, the complexity of the universe and the very secret of all existence.

This conception of landscape served as a model for the masters of the following generation, Altdorfer, Huber and Baldung who, however, added to Dürer's achievement their concentration on the romantic, visionary and fantastic element. With their use of high lights contrasted with darkness the effect was heightened, and Nature took on the aspect of a dream-world, peopled with dread, mythical beings. All sense of reality disappeared. In Altdorfer a literal transcription of Nature gave way to a more painterly effect: so subjective indeed is his conception of painting that one might almost regard it as an anticipation of the Romantic Movement.

The Italian, the classical ideal of closed, static form was foreign to the artists of the North. When Dürer in his "Discourse on Proportion" talks of the parts of the body as "flowing so wonderfully into one another" *("wie sie wunderbarlich ineinander gehen")* he unwittingly hits upon a fundamental aspect of northern art: for it is the rhythm of the whole body, with its various parts contributing to the general movement, which the northern artist seizes on, and around which he builds up his composition. The Italian Renaissance artist on the other hand is interested in the contrast of forms, in the existence of the individual figure, in the expression of corporeal reality: conceptions which are unknown to the German artist. The difference between the nudes of Botticelli, traced with that light and sinuous line, and those of Cranach, which at first sight appear somewhat similar, is in fact as great as that between the sensuous surface quality of a Correggio and the abstract expression of material substance in the work of that great German genius Matthias Gruenewald. For the German artist the body is a means of self-expression, not an end in itself: he does not attempt to achieve

9

the sensuousness, the tangibility, the flesh and blood quality of the Italian artist.

Northern Gothic, abstract, obscure and problematical, but charged with the inner fire of religious fervour, contrasts sharply with the sensuous, throbbing vitality of the art of the Italian Renaissance. And even when Dürer, seeking Faust-like to enjoy the best of both worlds, endeavours again and again to attain to the classical ideal, as did Goethe later, he does so, not by force of natural instinct, but with the protractor and compass, with the instruments of a cold calculating reason. The problem of uniting the two ideals always tempted him and, when eventually he found his solution he was able to produce the finest examples of figure painting of his own time — the draped figures of "The Four Apostles" (Plates 11, 12 & 13). Beside this German extension of the classical ideal of closed form there existed, too, the Gothic ideal. Beside the full, round, mighty figures of Dürer, drawn in broad and rhythmical curves, there stood the thin, angular, undeveloped figures of Cranach's girls. His goddesses of antiquity are chaste virgins who cast timid, furtive glances at the woods, they are not the full seductive creatures that we see displaying their charms in Italian art of this period. In each case, too, the technique differs. In Cranach's work the beauty lies in the rhythmic undulation of his line, in the delicacy of the movement: the figure, like an ornament, is set in its background whence it seems to grow, it is one with Nature. In Italian art it is the sensuous passion, the bodily self-assurance which are expressed in the attitude and features of the figure, which stands like a statue in relief against a magnificently constructed background.

It is only by understanding the spiritual personality and artistic achievements of Dürer that one can grasp the significance of German art at the time of the Reformation. The roots of the structure of the whole epoch are in Dürer: all the elements on which his pupils and contemporaries built were already present in his work. Attempts have been made to divide Dürer's personality into a German and Italian

10

side, to contrast the Protestant and Catholic in him; but these efforts have been fruitless, for so manifold a personality does not fall systematically into categories. Dürer was — and this was apparent in his own day — the first modern German artist, the first and perhaps the only German painter whose influence spread beyond the boundaries of his own land. For spiritual profundity and greatness of vision, and as an artist of universal significance, only one other man of his epoch — Leonardo — was his equal. With his liberation of the individual from the tyranny of ecclesiastical tradition the Middle Ages are at an end. But his real greatness consists in the fact that this liberation of the individual, and here he ranks beside Luther the reformer of the religious and political order, is followed by his incorporation in a new hierarchy of Dürer's own creation. With elements that were no longer present at the end of the 15th century he founded, in the course of the most unique phase in the whole history of German art, a northern classicism in the best sense of the phrase. This, the culmination of his development, shared, alas, with that of the Hohenstaufens two and a half centuries previously, and the heroic efforts of Luther, the fate of having been produced in an age not advanced enough to appreciate them. But when we reproach Dürer with having broken the continuity of his development to introduce the Italian element into German art after reaching such heights in his "Apocalypse", we forget that the formal restraint of the Italian was not for him the measure of his achievement, but rather a means to the deepening of his perceptions: one must remember too that he finally mastered it. This we know not only from his late work "The Four Apostles" but also from contemporaries both inside and outside Germany. Baldung, for example, who understood, was able to follow in Dürer's footsteps; it was only the weaker generation of artists that followed, those born about 1500, who mechanically copied the foreign model without knowing how to absorb it. The Italian artists of the generation of Raphael, attracted by the work of this strange young German who had come among them, learnt much from Dürer,

11

and thus it is that certain peculiarly German elements are present in the work of the Italian Mannerists. Although in Dürer's work the traditional themes and iconography of the Church are overshadowed by his portrayal of individuals, by his interest in landscape and by his greater approach to naturalism, it is clear that, despite this apparent materialism, the artist himself was not devoid of a depth of religious feeling. The most important document of the German Reformation, that which heralds the explosion to come and betrays the whole spiritual discord of this transition period, is not the series of portraits of the great reformers by Cranach, but the "Apocalypse" of the 27 year old Dürer. And as a last word of admonition to those indulging in the petty squabbles and differences of opinion which were threatening to destroy the great work on hand, he bequeathed to his native city of Nuremberg his pictures of "The Four Apostles".

The inexorable earnestness with which Dürer tackles the problem of art and its new direction in his theoretical treatises, his feeling of responsibility for his assimilation of the Italian ideal, his striving for perfection, for absolute beauty, for an ordered world, have not these traits always been associated with the greatest artists? Dürer represents the extreme development of individualism within a rigid framework capable of containing his forces of will, of spirit and of character. As though a continuous control were being exercised his whole work, like that of Rembrandt, is punctuated by a long series of self-portraits, with deep-set, searching eyes, turned in upon himself and yet proclaiming their belief in mankind as the standard and original form of all life. In the famous "Self-Portrait" (Plate 8) in Munich, where the figure, devoid of colour except for the clothes and hair, is set against a very dark background, the impressiveness of the whole depends on two things alone — the face, and the right hand resting on the fur collar, for the index finger, as in a mediaeval "Ecce Homo" is pointing upwards as though to indicate the other-worldly nature of his conception. The

12

human artist has here become superhuman, a link between earthliness and divinity, between the finite and the infinite.

Dürer had a direct influence on some of his immediate pupils; his ideas bore fruit and left their mark on the whole of German art in his day. The first generation of his pupils, those already closely associated with him before 1510, made use of many of his ideas of form and composition in their altar-pieces. The most talented disciple was undoubtedly Hans von Kulmbach whose "Adoration of The Kings" (Plate 15), painted in 1511 as the centre panel of his altar to The Virgin in the Church of Skalkau in Cracow, reveals in the general composition the classical spirit of Dürer, although to a certain extent it betrays the influence of his other master Jacopo de Barbari. His own individuality is however clearly seen in his severe portraits in the late Gothic style, such as that of The Margrave Casimir of Brandenburg, now in Munich, or the "Male Portrait" (Plate 14) now in Nuremberg. Another pupil Wolf Traut, who died young in 1520, reveals, in his gaily coloured Artelshofen altarpiece (Plate 17), his debt to his master, though, as regards the composition, his copying has been both clumsy and mannered. The Ober-St.-Veiter altarpiece of Hans Leonard Schaeufelein is so close to Dürer that a collaboration between master and pupil is here almost certain; at any rate Dürer must have prepared the cartoons. His influence is even more clearly seen in the two circular portraits in the Kunsthistorisches Museum in Vienna, or in the "Portrait of Sixtus Oelhafen" (Plate 16), which are visualised almost as woodcuts. The Swabian Master of Messkirch too, though later, belongs to the same group (Plates 20 & 21). He absorbed Dürer's ideas at second hand through his pupils, but he elaborated them into an individual though coarse style, which combines the primitiveness of his native tradition and a taste for warm colours. But whereas these few artists tried to follow more or less closely in the footsteps of the master, the pupils of the following generation, those whose connection with him dates from about 1520, such as Barthel Beham and Georg Pencz, examples of whose work are

reproduced here (Plates 18 & 19), though the source of their inspiration is not far to seek, represent a phase in the development of portrait painting which Pinder has rightly called "decoratively classical" as opposed to the true classicism of Dürer. Whereas Dürer assimilated the formal ideal of Italian art and infused it with the force and depth of his own experience and finally achieved a spiritual mastery over the Renaissance, these minor masters, whose real importance is in the sphere of graphic art, were responsible for that tendency to representative forms, to objectivism and to the adoption of artificial posturing in the manner of the Venetian painters, which temporarily swamped the natural German forms of expression.

The most interesting, and historically the most important, follower of Dürer, was Hans Baldung Grien, who was born in Swabia but was active for the most part in the region of the Upper Rhine. One can see in his work perhaps best of all the full flowering of the new spirit in German art, and also its subsequent blight at the time of the Reformation. Born about the same time as Raphael he stands, in contrast to the serious and more problematical innovators among his contemporaries, as the embodiment of the spirit of joyful receptivity *(freudige Weltoffenheit)* and freedom from restraint; his works are both beautiful and harmonious. The whole range of thoughts and experiences of his age are reflected in the work of Baldung who, as we know from documents and from his own pictures, was not only in close contact with the foremost Humanists of his day, but indeed was actively concerned with the Reformation. Dürer's influence on him dates from the period of his studies in Nuremberg between 1503 and 1507: he evolved however a quite personal style of painting, which, although not approaching the intensity of his master shows, in point of development, a looser conception of form and a greater emphasis on linear rhythm in contrast to Dürer's essentially plastic but firm delineation of form. This loosening of contours and general animation of line is accompanied by a tendency to strange effects of light, as well as by an

interest in allegorical and mythological subjects. But his work, with its pleasant air of *rêverie,* sometimes takes on a nightmarish quality, as in his many black and white compositions of the "Witches' Sabbath" or in the various versions of "Death and The Maiden": here the dramatic exploitation of the combined lust for life and the chill blast of death betrays, only too clearly, the spiritual tension at the time of the Reformation.

These characteristics are peculiar to the School of the Upper Rhine at this date. Although the choice of subject was to some extent due to Italian influence, the form in which it was expressed is typical of German late Gothic style. This is well exemplified by that compact group of Swiss artists Hans Fries, Hans Leu the younger, Niklaus Manuel (called Deutsch) and Urs Graf, by whom we possess a mass of drawings and woodcuts but no absolutely authentic pictures. An expressive use of late Gothic linear rhythm is common to all these artists: they also had quite a modern conception of landscape and preferred themes taken from mythology, as for example the beautiful "Orpheus" (Plate 37) by Hans Leu or "The Judgment of Paris" (Plate 34) by Niklaus Manuel. These pictures are executed with the lightness of touch peculiar to these artists and they have a natural, fresh charm: their idyllic almost fairy-like quality reminds one of the best artists of the Danube School who were also active at the same period.

But before proceeding further in this direction we must pause to consider that strangest of all apparitions in the history of German painting: namely Matthias Gothart Nithart called Gruenewald. Artistically he was the direct antithesis of Dürer. Little is known of his origin: his masterwork was the altar-piece for the Antonite monastery of Isenheim near Colmar in Alsace. It would be a misconception of German art to neglect the distance which separates its two poles of artistic expression: for there is no absolute standard by which we can measure both Dürer and Gruenewald. Like a meteor Gruenewald shoots across the firmament of German art, revealing the infinite width and depth of the artistic experience of the German people, just at that moment

when through the personal influence of one individual it was beginning to assume a certain unity. In contrast to the rational and humanistic Dürer, Gruenewald represents the mystic, the visionary burning with religious fervour, existing on a totally different plane of consciousness from the great German mystics before him, but sharing their feeling of the irrationality of this world. One might say that Gruenewald follows to its climax the path of development abandoned by Dürer after the production of "The Apocalypse" in 1498. Gruenewald's technique, his strange effects of illumination, produced by an intensive use of colour, and his startling contrast of light and shade are unparallelled in German painting. He depends for his effect in his pictures, and also in his drawings, on the vibratory quality of graded colour: thus it is not surprising that we possess no engravings or woodcuts by him. He bases his compositions on a contrapuntal division of colour which sets the key to his mood and indeed heightens the pathos of his supreme conceptions. This tendency which is present in his earliest works such as the "Crucifixions" in Basle and in the Koenig collection in Harlem (Plate 38), reaches its climax in the Isenheim altarpiece (Plates 40-47) which was painted about 1513. In his later works such as the panel from the "Maria Schnee Altarpiece" (Plate 48) or "The Conversion of St. Maurice" (Plate 50), now in Munich, a more perfect pictorial and tonal harmony is attained, but the principle remains constant to the end of his life. A comparison of his portrait of Cardinal Albrecht of Brandenburg (Plate 50), painted in 1525, with Dürer's "Portrait of Wilibald Pirkheimer", which was finished one year previously, offers clear proof of their difference of aim. Gruenewald's death, a tragedy for the development of German art, occurred in 1528, in the same year as that of Dürer. Four years later Holbein left Germany for ever, and by then the art of Cranach and Baldung had degenerated into a mere sterile mannerism.

Cranach, a Frank by birth, and later Court painter at Wittenberg in Saxony, was born, one year after Dürer, in 1472. He was the friend

and portraitist of the great Reformers Luther and Melanchthon. His visit to Vienna from 1502 till 1504 was largely responsible for the growth of the so-called Danube School. It is only of recent date and as a result of a re-examination of his early work that the reputation of this somewhat crude and mechanical artist has grown. His late work became increasingly shallow and studio produced, but his early work contains qualities which exercised a lasting influence on German art. His style owes much, as far as we can see today, to the effect made on him by the progressive, late 15th century, artists of the Ostmark School, such as Pacher, Reichlich, Fruehauf and others, also to Dürer's "Apocalypse". There is great emotional tension and spiritual fullness in Cranach's early works, of which in the present volume we reproduce "The Crucifixion" (Plate 51), the portraits of Johannes and Anna Cuspinian (Plates 52 & 53) and "The Flight into Egypt" (Plate 54). With a feeling for Nature unknown in the 15th century, figures and landscape are here woven together: by means of a high luminosity of colour, a complicated arrangement of forms and great intensity of feeling, he produced a form of picture which was quite new in German painting. The naïve directness of these early works, expressions of a quick and resolute comprehension, soon vanishes after his appointment as Court painter, in 1505. It has rightly been pointed out that, just at the moment when his unique personality was beginning to assert itself, it was engulfed by an enormous, almost mediaeval, studio activity. Many of these studio productions certainly reveal a freshness of invention and a real artistic sensibility in the painting of landscape, but in general the compositions are formalised and empty, and there is an increasing feeling of impersonality and deadness. The whole style of the North East German Schools is based on Cranach's late style; one need only examine for instance the work of Crispin Herrant, a one-time pupil of Dürer, and Court painter to the Dukes of Prussia in Koenigsberg, whose portrait of the astronomer Carion (Plate 60) is a typical example of Cranach's influence.

Although it is improbable that Cranach had direct contact with the painters of the Danube School there is, nevertheless, between their work and Cranach's early style, a considerable resemblance, due probably to considerations of locality, which reveals itself in the general aspect, in the naïve interest in narrative and in the sensitive handling of landscape. With Altdorfer and Huber as its leaders and counting among its adherents Hans Wertinger, Michael Ostendorfer, Melchior Feselein, Hans Mielich, The Master A.G. of 1540 and Konrad Faber von Kreuznach, this school occupies quite a definite place in the history of German art in the 16th century. The Danube School is distinguished by its preference for idyllic, romantic subjects and by its neglect of religious subjects, thus accounting for the small size of most of its productions. The sinuous quality of its line, its treatment of landscape and clouds and the essentially painterly nature of its style reminds one somewhat of the School of the Upper Rhine. But when we speak of the painterliness of Altdorfer's work we do not mean the same quality as when talking of Italian art. The great achievement of the Italians at the beginning of the Cinquecento was *"sfumato"* that uniform effect of soft light which pervades all the forms in the composition alike, as in the work of Correggio. The German artist never sought after this effect. What is meant by the painterly quality of 16th century German art is that way of relating the perspective plane to the foreground by a use of clair-obscur. That is to say, that as in late Gothic carved altarpieces, the general impression is of a chequered effect, an alternation of patches of light and shade, not of a uniform illumination. The technique is fundamentally that of the black and white artist.

The centre of the Swabian School shifted, at the beginning of the 16th century, from Ulm to Augsburg, the centre of German trade and the favourite city of the Emperors Maximilian and Charles V, under whom it became very powerful. A typical artist of the School of Ulm at the beginning of the century is Martin Schaffner. This artist who was influenced by Burgkmair had a freer, less conventional style than his slightly

18

older contemporary Zeitblom. He combined elements of the late Gothic style with a newer conception of the representation of figures in space. His work is simple and unpretentious: examine, for example, the two wings from the High Altar of Ulm, painted in 1521, and those from the altarpiece of the monastery of Wettenhausen (Plate 89). Bernard Strigel and Hans Maler zu Schwaz in their peculiarly confident and finely delineated portraits, with pallid flesh tints, of the members of the House of Habsburg, and of the noble families of Augsburg, show that they are practically free from the prevailing Italian influence. Another original artist Jerg Ratgeb was active in North Swabia: his style though reminiscent of Gruenewald is more akin to that of the 15th masters of the Ostmark School. But the pleasant decorativeness of his Schwaigern altarpiece (Plate 30), painted in 1511, degenerated by 1519 into the coarsely exaggerated forms of his Herrenberg altarpiece now in Stuttgart (Plate 31).

The leader of the School of Augsburg in Dürer's day was Hans Burgkmair, for, although, after 1510, his work does certainly lean more towards the newer tendencies, Hans Holbein the Elder was fundamentally a product of the 15th century. Burgkmair on the other hand is a typical artist of the new school: he has a strong feeling for colour and tone, a fine sense of form in space and a love of splendour and decorative breadth. It is interesting to observe how differently Dürer and Burgkmair treat the Renaissance element. Whereas Dürer tried to reconcile the basic abstract principle with his own natural form of expression, Burgkmair, who too must have been in Italy about 1506, took over the model as it stood and invested it with the full measure of his own sensibility. The monumental type of human figure, a delight in the magnificence of outward appearances, and above all many typical Renaissance decorative elements become from then on an integral part of the Augsburg style. In contrast to the reasoned unity of Dürer's pictures there begin to appear works like "The Madonna and Child" (Plate 78) painted by Burgkmair in 1509, where the figures are no longer part

of the landscape, but in which the brilliant range of colour and warmth of tone render them more imposing, more naturalistic and more pleasing.

The spirit of the Augsburg renaissance under the Emperor Maximilian is perhaps best of all illustrated by Leonard Beck's "St. George" (Plate 83), now in Vienna, which is the only painting which can with certainty be attributed to this artist who worked primarily as an engraver. Joerg Breu the Elder, too, had quite an individual style when, as a young man, he journeyed up the Danube (1500—05); but he later fell more and more under the influence of Burgkmair. Ulrich Apt the Elder (Plate 85) with his broad planes of full luminous colour and his decorativeness is typical of the School of Augsburg. Closely related to him is an artist whose real name is still unknown, the Master of the Angrer Portraits, the author of some fine robust male portraits (Plate 86). Christoph Amberger is the most important portraitist of the School (Plate 87), and particularly in his later work he attained a magnificence, a nobility of attitude and a harmonious unity of colour which is only comparable to that of his contemporaries Paris Bordone and Titian.

Hans Holbein the Younger, the greatest son of Augsburg, appeared a generation later than Burgkmair. His achievements are unthinkable without the background of his native tradition and above all without the tuition of his father Hans Holbein the Elder, who, in his later years, himself absorbed something of the spirit of the new epoch; yet Holbein the Younger was to exercise a considerable influence far beyond the narrow confines of his native city. As early as 1515 he was in Basle, and it is after this that his style develops into that extraordinary synthesis of elements taken both from the School of the Upper Rhine and from the North Italian Schools. His Augsburg heritage too is easily recognised in the full, glowing colours of two of his early works: "The Solothurn Madonna" (Plate 94) and "The Virgin with the family of Burgomaster Meyer" (Plate 95). But in the treatment of the heads in these pictures there is already present that feature of Holbein's style which became so marked in his later productions and which is otherwise

20

unknown in German painting: his cold objective analysis of a face and his purely linear expression of it. Holbein resembles Dürer in his unceasing study of Nature; witness his large series of drawings. But the difference between these two artists lies in the dispassionate objectivism, in the intellectual detachment which divides the artist from his subject, whose character is expressed in an almost impersonal manner in terms of pure form. Thus Holbein stands outside the range of the German Schools of painting of his own day, and in fact in his own country he had no followers. In England and in the Netherlands his style was continued in an uncreative, eclectic form. But Holbein was not an isolated phenomenon in his own time, for as contemporaries one can point to the Italian Mannerists Pontormo and Bronzino, who were Florentine Court painters, and to the French portraitist Clouet.

BIBLIOGRAPHY

General Literature

Sandrart, Joachim von: Academie der Bau-, Bild- und Malerey-Kuenste von 1675. Edited with a commentary by A. Peltzer. Munich, 1925.

Dehio, Georg: Geschichte der deutschen Kunst. Vol. 2. 2 nd. ed. Berlin, 1931.

Burger-Schmitz-Beth: Die deutsche Malerei vom ausgehenden Mittelalter bis zum Ende der Renaissance. Handbuch der Kunstwissenschaft. Vol. 3. Berlin, 1917.

Glaser, Curt: Die altdeutsche Malerei. Munich, 1924.

Heidrich, Ernst: Die altdeutsche Malerei. Jena, 1909.

Voss, Hermann: Ursprung des Donaustils. Leipzig, 1907.

Ganz, Paul: Malerei der Fruehrenaissance in der Schweiz. Zurich, 1924.

Beitraege zur Geschichte der deutschen Kunst. Edited by E. Buchner and K. Feuchtmayr. Augsburg, 1924—28. (Refered to as "Beitraege".)

Rott, Hans: Quellen und Forschungen zur Kunstgeschichte im XV. und XVI. Jahrhundert. Stuttgart, 1933—34.

Kuhn, Ch. L.: A catalogue of German paintings of the middle Ages and Renaissance in American collections. Cambridge (Mass.), 1936.

Allgemeines Lexikon der bildenden Kuenstler. Founded by U. Thieme and F. Becker. Leipzig, 1907 ff.

Literature relating to individual artists

ALTDORFER: M. J. Friedlaender, Albrecht Altdorfer. Berlin, undated.
H. Tietze, Albrecht Altdorfer. Leipzig, 1923.

BALDUNG-GRIEN: G. von Térey. Die Gemaelde des Hans Baldung gen. Grien. Strassburg, 1896—1900.
H. Curjel, Hans Baldung Grien. Munich, 1923.

BURGKMAIR: Feuchtmayr. Das Malerwerk Hans Burgkmairs von Augsburg. Preface to the Catalogue of the Burgkmair Exhibition at Augsburg in 1931.

CRANACH: Flechsig, Cranach-Studien. 1900.
H. Michaelson, Lucas Cranach der Aeltere. 1902.
C. Glaser, Lucas Cranach. Leipzig, 1921.
M. J. Friedlaender and J. Rosenberg, Die Gemaelde von Lucas Cranach. Berlin, 1932.

DÜRER: M. Thausing, Albrecht Dürer, his life and Work. Trans. from German by F. H. Eaton. 2 vols. London, 1882.
H. Woelfflin, Die Kunst Albrecht Dürers. 5th. ed. Munich, 1926.
M. J. Friedlaender, Albrecht Dürer. Leipzig, 1921.
F. Winkler, Dürer, des Meisters Gemaelde, Kupferstiche und Holzschnitte. Introduction by V. Scherer. Klassiker der Kunst, Vol. 4. 4th. ed. Stuttgart, 1928.
H. Tietze and E. Tietze-Conrath, Kritisches Verzeichnis der Werke Albrecht Dürers. Vol. 1. Der junge Dürer. Augsburg 1928.
E. Flechsig, Albrecht Dürer, sein Leben und seine kuenstlerische Entwicklung. Berlin, 1928—30.
W. Waetzoldt, Dürer und seine Zeit. Wien, 1935.

GRUENEWALD: H. A. Schmid, Die Gemaelde und Zeichnungen des Matthias Gruenewald. Strassburg, 1911.
M. J. Friedlaender, Der Isenheimer Altar. Munich, undated.
O. Hagen, Matthias Gruenewald. Munich, 1919.
A. Burkhard, Matthias Gruenewald, Personality and Accomplishment. Cambridge (Mass.), 1936.

HOLBEIN: A. Woltmann, Holbein and his time. Trans. F. E. Bunnett. London, 1872.
P. Ganz, Hans Holbein der Juengere, des Meisters Gemaelde. Klassiker der Kunst. Vol. 20. Stuttgart, 1912.
Stein, Hans Holbein der Juengere. Berlin, 1929.

HUBER: M. Weinberger, Wolfgang Huber. Leipzig, 1930.

ANNOTATED LIST
OF ARTISTS AND PICTURES

Heinrich Aldegrever

1502—1562. Westphalian School; active in Soest.

Portrait of an elderly man

Bremen, Roselius-Haus

This is a picture of the Westphalian or Lower Saxon School, but it cannot with certainty be attributed to Aldegrever (Vide F. Winkler and O. Plamberg "Das Roselius-Haus in Bremen", 1930, p. 15f). The group of portraits by The Master A. G. of 1540 (Pl. 73), formerly attributed to Aldegrever, have now been definitely proved to be South German. Plate 103

Albrecht Altdorfer

c. 1480—1538. Danube School; active in Regensburg.

The Virgin and Child with S.S. Joseph and John the Evangelist

Vienna, Kunsthistorisches Museum

Wood 22.5×20.5 cm. With monogram and date 1515. Plate 61

The Madonna and Child

Berlin, Private Collection

Wood 33.5×22.2 cm. Painted c. 1516. Vide Winkler "Altdorfers Gemaelde, Der Erste Schritt" in Pantheon IX, 1932, p. 44 ff. Plate 64

Christ taking leave of His Mother

London, Collection of Lady Wernher

Wood 135×126 cm. This picture formerly in the collection of the last Prince Abbot of St. Emmeram, and supposedly of 1522, is placed by Friedlaender (op. cit. p. 80f) contemporary with the altarpiece of St. Florian and dated probably correctly c. 1517; Tietze agrees. Plate 62

The Resurrection

Vienna, Kunsthistorisches Museum

Wood 70.5×37.3 cm. Dated 1518. This picture and its companion "The Deposition" come from the monastery of St. Florian, Upper Austria. They formed part of a polyptych of which eight large scenes of The Passion, four scenes from The Life of St. Sebastian and two smaller panels with S. S. Barbara and Margaret and the kneeling figure of the abbot Peter are still preserved there in the gallery. Proof exists of the donation of an altar in 1509 under abbot Peter, and the date 1518 would be that of the completion of the paintings. Plate 63

The Battle of Arbela (Detail)

Munich, Aeltere Pinakothek

Wood 158×120 cm. With monogram and date 1529. One of the series of historical scenes painted for Duke Wilhelm IV, others of which, by Barthel Beham, Breu, Burgkmair, Feselen, Refinger, and Schoepfer are now in Munich, Stockholm and Schleissheim. Plate 65

The Nativity

Berlin, Deutsches Museum

Wood 129×91 cm. c. 1525. Vide H. Voss in Jahrbuch der Preuss. Kunstsammlungen 1933, 54, p. 1 ff. Plate 66

Landscape

Munich, Aeltere Pinakothek

Paper on wood. 30×22 cm. c. 1532. Plate 67

Christoph Amberger

c. 1500—1561. School of Augsburg.

Portrait of Matthaeus Schwartz

Berlin, Galerie Haberstock

Wood 74.5×61.5 cm. Dated 1542. The sitter was a confidant of the House of Fugger. Painted under the influence of the Venetian School, in particular of Paris Bordone: cf. portraits of Fugger in Munich, Baumgartner in Vienna and Sulzer in Gotha. Formerly in collections von Ritzenberg (Nischwitz-Vienna), von Friesen (Dresden), Schubart (Munich), Hirsch (London). Vide Baldass "Christoph Amberger als Portraitmaler" in Pantheon, V, 1932, p. 177 ff. Plate 87

Ulrich Apt the Elder

c. 1460—1532. School of Augsburg, and a Master there after 1486.

The Adoration of the Kings

Paris, Louvre

Wood 125×71 cm. Wing of an altarpiece put up in 1510 in the Church of The Holy

Cross in Augsburg, supposedly donated by Martin Weiss but now (Vide F. Thoene in Pantheon XIII, Jan. 1935) attributed to the Weavers' Guild. The central panel has been lost, but the other wing representing "The Nativity", though cut at the top and down one side, is now in Windsor Castle.

Plate 85

Hans Baldung Grien

1484—1545. School of the Upper Rhine. Influenced by Dürer. Active in Strassburg and Freiburg.

Self-Portrait (Detail from The Sebastian Altarpiece).
Nuremberg, Germanisches National Museum
Wood 118×78 cm. 1507. Plate 22

The Adoration of the Kings
Berlin, Deutsches Museum
Wood 121×70 cm. Centre panel of an altarpiece from the Stadtkirche in Halle; in style resembling the Sebastian Altarpiece in Nuremberg. Plate 23

The Allegory of Vanity
Vienna, Kunsthistorisches Museum
Wood 48×32.5 cm. c. 1510. Doubts as to the authenticity of this picture expressed by Curjel (op. cit.) are not upheld by Baldass, Buchner or Friedlaender. The same theme is treated by the artist in a drawing of 1515, now in the British Museum, London.
 Plate 24

The High Altar of Freiburg Cathedral
The Coronation of The Virgin — The Head of God The Father (Detail) — The Nativity (Detail)
Wood: Centre panel 285×231 cm; wings 289×101 cm. Completed 1516.
 Plates 25—27

Portrait of Graf von Loewenstein
Berlin, Deutsches Museum
Wood 46×33 cm. With monogram and date 1513. Plate 28

Pyramus and Thisbe
Berlin, Deutsches Museum
Wood 93×67 cm. c. 1530. Sold at Vienna auction in 1919 as Altdorfer. Plate 29

Leonhard Beck

c. 1475—1542. School of Augsburg. Influenced by Burgkmair.

St. George fighting the Dragon
Vienna, Kunsthistorisches Museum
Wood 134.5×116 cm. c. 1511. The angel added c. 1600. Plate 83

Barthel Beham

1502—1540. Born in Nuremberg. Active in Munich after 1527.

Portrait of Ludwig X of Bavaria
Vienna, Liechtenstein Gallery
Wood 69×58 cm. Plate 18

Joerg Breu the Elder

c. 1480—1536. School of Augsburg. Influenced by Burgkmair.

Christ taken Prisoner
Melk, Praelaturkapelle
Wood 134×95 cm. Panel from an altar erected in 1502 in Wullersdorf, Lower Austria. Vide E. Buchner "Der aeltere Breu als Maler" in Beitraege (op. cit.) p. 272 ff.
 Plate 81

The visit of the Virgin to St. Elizabeth
Budapest, Gemaeldegalerie
Wood 139×95 cm. c. 1505. Plate 82

Bartholomaeus Bruyn the Elder

1493—c. 1553. School of Cologne: active there from 1515.

Portrait of a girl
Munich, Julius Boehler
Wood 36×25 cm. Formerly coll. Joseph Cremer, Dortmund. Plate 102

Hans Burgkmair

1473—1531. School of Augsburg. Elected to the painters' guild there in 1498. Pupil of Thoman Burgkmair and Martin Schongauer.

Portrait of Hans Schellenberger, citizen of Augsburg
Cologne, Wallraf-Richartz Museum (Coll. Carstanjen)
Wood 40×27 cm. Dated 1505. Acquired in 1934 from The Hermitage, Leningrad, together with the companion portrait of his wife Barbara Ehem, dated 1507. Vide F. Winkler in Pantheon VII, 1934, p. 169 ff.
 Plate 77

The Madonna and Child
Nuremberg, Germanisches National Museum
Wood 164×100 cm. Dated 1509. Plate 78

Landscape: detail from the centre panel of The Crucifixion Altarpiece
Munich, Aeltere Pinakothek
Wood 178×116 cm. Dated 1519. Plate 79

Lucas Cranach the Elder

1472—1553. From 1505 Court Painter to the Elector of Saxony. Active chiefly in Wittenberg; 1502—04 in Vienna: 1508 in the Netherlands: 1550—52 in Innsbruck and Augsburg. Died in Weimar.

The Crucifixion (Detail)
Munich, Aeltere Pinakothek

Wood 138×99 cm. Dated 1503. In Bavarian State possession since the dissolution of the monasteries in 1801. Plate 51

Portraits of the historian Dr. Johannes Cuspinian and his wife Anna
Winterthur, Coll. Oscar Reinhart

Wood 59×45 cm. c. 1502. Formerly in the collection of King Charles I of England.
Plates 52—53

The Flight into Egypt
Berlin, Deutsches Museum

Wood 69×51 cm. With monogram L. C. and date 1504. Plate 54

The Madonna and Child under the fir trees
Breslau, Cathedral

Wood 71×51 cm. With monogram L. C. c. 1510. Indicative of a renewed influence of Dürer at this time: cf. The Madonna on the Dresden Altarpiece (Pl. 2) then in the Castle Church of Wittenberg. Plate 55

Portrait of The Elector Frederick the Wise
Berlin, Galerie Haberstock

Wood 55×35 cm. With painter's mark. c. 1515. Formerly in possession of the royal House of Saxony, Schloss Sibyllenort. The earliest of the numerous portraits of the Elector painted by Cranach. Plate 56

The Judgment of Paris
Formerly coll. Baron v. Schenk, Burg Flechtingen, near Magdeburg

Wood 63.5×41 cm. c. 1516. Plate 57

Nymph resting beside a spring
Lugano, Coll. Baron Thyssen-Bornemisza

Wood 73×119 cm. c. 1528. Formerly in coll. Truebner (1918) and Galerie Haberstock, Berlin. Plate 58

Portrait of Hans Luther, father of Martin Luther
Wartburg, near Eisenach

Wood 37.5×24.5 cm. With artist's mark and date 1527. Acquired in 1841 with the portrait of Luther's mother by the Arch-

duchess of Sachsen-Weimar. The coloured study for this picture is in the Albertina, Vienna. Plate 59

Albrecht Dürer

1471—1528. School of Nuremberg. Pupil of Michael Wolgemut. 1490—94 journeying through South Germany to Alsace and Basle; in Italy 1495 and again 1505—06; in the Netherlands 1520—21.

Albrecht Dürer, the artist's father (Detail)
Florence, Uffizi

Wood 123×89 cm. Signature and date 1490 added later. The portrait shows the artist's father, a goldsmith from Eytasch in Hungary, at the age of 63. Other portraits of his father are the silverpoint drawing of c. 1486 in the Albertina, Vienna, and the picture of 1497 in the National Gallery, London. Plate 1

The Madonna and Child: detail of the centre panel of The Dresden Altarpiece
Dresden, Gemaeldegalerie

Canvas 95×105 cm. 1486. Generally supposed to have been done for Frederick the Wise. Till 1687 in the Castle Church of Wittenberg. Plate 2

The Madonna and Child: and on the reverse The Flight of Lot with his daughters
Lugano, Coll. Baron Thyssen-Bornemisza

Wood 52×41 cm. Acquired at a London auction 1932 from English private collection as Bellini, whose influence on the young Dürer is here clearly marked. The coat of arms on the left is that of the Nuremberg family Haller von Hallerstein. Friedlaender (Vide Pantheon VII, 1934, p. 321 ff.) suggests c. 1500 as the correct date. Plates 4—5

The Dead Christ (Detail)
Munich, Aeltere Pinakothek

Wood 151×121 cm. c. 1500. Probably originally donated to the Predigerkirche in Nuremberg by the goldsmith Gleim. Acquired c. 1600 from the Imhofscher Kunstkammer by Duke Maximilian of Bavaria.
Plate 3

The Adoration of the Kings (Detail)
Florence, Uffizi

Wood 98×112 cm. With monogram and date 1504. Presented to Emperor Rudolf II from the Castle Church of Wittenberg; acquired by Florence in 1792. Plate 6

Portrait of a Venetian Lady
Vienna, Kunsthistorisches Museum
Wood 35×26 cm. With monogram and date
1505. Earliest known work of his second
Venice period: unfinished. Bought in 1923
by Vienna Museum from a private collec-
tion in Lithuania. Plate 7

Self-Portrait
Munich, Aeltere Pinakothek
Wood 65×48 cm. With monogram and
date 1500, also inscription: all added later.
The date of this picture is uncertain: some
writers think it was started during his
second visit to Italy, others that it is later.
The latest authorities however favour some
date c. 1500. Plate 8

The Madonna of the Crowns of
Roses (Detail)
Prague, Gemaeldegalerie
Wood 162×194 cm. Dated 1506. Chief
work of his second Venice period. Till end
of 16th. cent. was in San Bartolommeo, the
German Church in Venice. After several
changes of ownership it was bought by the
Strahow Monastery in Prague. Bought by
the gallery there in 1934. Plate 9

Portrait of Wilibald Pirkheimer
Madrid, Prado
Wood 50×36 cm. Dated 1524. The identity
of the sitter is disputed: the date, misread
as 1521, suggested one of Dürer's acquaint-
ances in the Netherlands. Now Rentmeister
Lorenz Sterck is suggested as alternative to
Pirkheimer. Plate 10

The Four Apostles
Munich, Aeltere Pinakothek
Wood. Each panel 204×74 cm. Presented
by Dürer to the Council of Nuremberg in
1526 as a legacy to his native town. After
1627 acquired by the Elector Maximilian
of Bavaria. For explanation of the inscrip-
tions vide E. Heidrich "Dürer und die Re-
formation", 1909. Plates 11—13

Conrad Faber
(Called Faber von Kreuznach)
c. 1500—1552. Active after 1525 in Frankfort
on Main. Identified as "The Master of the Holz-
hausen Portraits".

Portrait of Justinian and Anna
von Holzhausen
Frankfort on Main, Staedel Institute
Wood 69×98 cm. Dated 1536. In the back-

ground a view of the city of Munich during
the siege of 1535 in which von Holzhausen
commanded the Frankfort troops. Plate 72

Melchior Feselein
Active in Ingolstadt after 1521. Died 1538.

St. George
Leipzig, Museum der bildenden Kuenste
Wood 54.5×66 cm. Signed M. F. Formerly
coll. Marcuard, Florence. Plate 74

Hans Fries
c. 1465 — after 1518. Active in Freiburg in
Schwerin, Basle and Berne.

Two Visions of St. John the Divine
Zurich, Landesmuseum
Wood. Each panel 130×32 cm. c. 1505.
The interiors of two wings of an altarpiece:
centre panel unknown. Plate 32

The Martyrdom of St. Barbara
(Detail)
Freiburg, Saxony, Museum
Wood 100×65 cm. Plate 33

Hans Funk
1470—1539. Active in Zurich and Berne.

Portrait of a young man
Vienna, Akademie der bildenden Kuenste
Wood 39×34 cm. With monogram and date
1524. The Kunsthalle, Basle (No. 234) has
a very similar portrait of a man also signed
and dated 1524, but different in size.
Plate 36

Lucas Furtenagel
School of Augsburg, first half of 16th century,
influenced by Burgkmair.

Portrait of the painter Hans Burgk-
mair and his wife
Vienna, Kunsthistorisches Museum
Wood 62×52 cm. Dated 1529. Until now
this picture has been considered to be a self
portrait of Hans Burgkmair. The false
signature has recently been removed.
Plate 80

Matthias Gruenewald
c. 1475 — c. 1529. Active in Middle Rhineland
and Upper Alsace: later in Halle with Cardinal
Albrecht von Brandenburg. The latest researches
tend to identify him with the master Mathis
Gothart Nithart.

The Crucifixion
Haarlem, Coll. Koenig
Wood 61×45 cm. An early work of the
master; a later version of the Crucifixion
in Basle. Plate 38

Chrispin Herrant

Pupil of Dürer, also influenced by Cranach. From 1529 chief Court painter to Duke Albrecht in Koenigsberg, Prussia. Died there 1549.

Hans Holbein the Younger

1497—1543. Born in Augsburg, 1515 in Basle, 1526 in London: here he became Court Painter in 1536 and remained permanently with interruptions 1528—31 and again 1538 when he was in Basle.

The wife and children of the artist
Basle, Oeffentliche Kunstsammlung
Paper on wood 70.5×65.5 cm. Dated 152(8).
Plate 97

Portrait of the merchant Georg
Gisze
Berlin, Deutsches Museum
Wood 96×84 cm. Dated 1532. Plate 98

Portrait of Robert Cheeseman,
Falconer to King Henry VIII.
The Hague, Mauritshuis
Wood 59×62.5 cm. Dated 1533. Plate 99

Portrait of King Edward VI as a child
Washington, Coll. Andrew W. Mellon
Wood 55.5×43 cm. c. 1538. Formerly in
Hannover, Welfenmuseum. Plate 100

Daniel Hopfer
School of Augsburg. Active 1493—1536.

The Annunciation
Augsburg, St. Jacob
Wood 158×104 cm. Plate 84

Wolf Huber
c. 1490—1553. Danube School. Active in Feld-
kirch and Passau.

Christ taking leave of His Mother
Vienna, Kunsthistorisches Museum
Wood 37.5×27.5 cm. Dated 1519. Plate 69

Christ on the Mount of Olives
Munich, Aeltere Pinakothek
Wood 60×68 cm. c. 1530. One wing of
an altarpiece the other wing of which
"Christ taken Prisoner" is also in Munich.
Plate 70

Portrait of the Humanist Jakob
Ziegler (1470—1549)
Vienna, Kunsthistorisches Museum
Wood 58.5×44 cm. The date 1537 is a
later addition. Painted during the theo-
logian's visit (1544—49) to the Bishop of
Passau. Plate 71

Hans von Kulmbach
c. 1480—1522. Active in Kulmbach and Nurem-
berg: 1514—16 in Cracow. Pupil of Jacopo de
Barbari and Albrecht Dürer.

The Adoration of the Kings
Berlin, Deutsches Museum
Wood 153×110 cm. With monogram and
date 1511. Centre panel of the altar to
The Virgin in the Church of Skalkau in
Cracow. Fragments of the wings still in
Cracow. Plate 15

Portrait of a man
Nuremberg, Germanisches National Museum
Wood 36.6×26.6 cm. c. 1521, Vide E.
Buchner "Hans von Kulmbach als Bildnis-
maler" in Pantheon, 1928, p. 135 ff.
Plate 14

Hans Leu the Younger
c. 1490—1531. Active in Zurich. Pupil of his
father Hans Leu the Elder; influenced by Dürer
and Baldung.

Orpheus and the animals
Basle, Oeffentliche Kunstsammlung
Canvas on wood 58×51 cm. With artist's
mark and date 1519. Plate 37

Hans Maler
(called Maler zu Schwaz)
School of Ulm. Active 1519—29 at Schwaz in
Tirol. Probably a pupil of Zeitblom and Strigel.

Portrait of a young man
Vienna, Kunsthistorisches Museum
Wood 37×31 cm. Dated 1521. Plate 91

Niklaus Manuel (called Deutsch)
c. 1484—1536. School of Berne. Influenced by
Hans Fries. Painter, draughtsman, poet and
statesman.

The Workshop of St. Eloy
Sarasota, John G. Ringling Museum (Photo
by permission of Julius Boehler, Munich)
Wood 120.5×83.5 cm. With artist's mark
and date 1515; probably formed part of
the altarpiece of the Berne Lux and Loyen
Brotherhood known to have been in the
Predigerkirche in Berne in 1518. The
reverse, now separated, shows "The Meeting
under the Golden Gate". One wing is in the
Berne Museum and shows on the outside
"St. Luke painting The Virgin" and inside
"The Birth of The Virgin". The centre piece,
almost certainly carved, cannot be traced.
Vide W. Hugelshofer "Ein Altarflügel des
Niklaus Manuel Deutsch von Bern" in
Pantheon, 1930, p. 346 ff. Plate 35

The Judgment of Paris
Basle, Oeffentliche Kunstsammlung
Canvas 218×158 cm. c. 1517. Plate 34

The Master A. G. of 1540
School of Augsburg. Active in second quarter of
16th. cent.

Portrait of a young man
Vienna, Liechtenstein Gallery
Wood 59×51 cm. Initialled "A. G." and
dated 1540. For a discussion of the problem

30

of this master vide Benesch ("Beitraege zur oberschwaebischen Bildnismalerei" in Jahrbuch der Preussischen Kunstsammlungen, 54, 1933, p. 239 ff.) who, following Buchner, rightly emphasises the similarity to Breu the Elder and Beck. Because of the monogram hitherto attributed to Aldegrever. Plate 73

The Master
of the Angrer Portraits

Active in Augsburg at the beginning of the 16th. cent.

Portrait of a man

Dresden, Gemaeldegalerie

Wood 61.5×44.5 cm. With reference to this master vide Feuchtmayr "Apt-Studien" in Beitraege (op. cit.) II, 1928, p. 97 ff. L. Baldass (Studien zur Augsburger Portraitmalerei des 16. Jahrhunderts in Pantheon, 1929, p. 393 ff.) seeks to identify him with Ulrich Apt the Younger, the probable author of the Augsburg Rehling altarpiece of 1517. Friedlaender who originally, in his book on Altdorfer, opposed this theory, first put forward by W. Schmidt in Rep. f. Kunstw. XIII, p. 273 f., does not refer to this master in his recent article in Cicerone, 1929, p. 1 ff. Plate 86

The Master of Messkirch

Upper Swabian School. Active in Messkirch 1500—1543. Combines influence of School of Nuremberg (Schaeufelein and Kulmbach) and School of Augsburg.

Portrait of Graf Gottfried Werner and Graefin Appolonia von Zimmern

Donaueschingen, Galerie

Wood: each panel 68×28 cm. Dated 1536. The interiors of two wings of the Wildenstein altarpiece. Sometimes identified as Joerg Ziegler or Marx Weiss: Roth (op. cit.) suggests dividing his work between these two artists. But for fuller discussion of this Master vide Feuerstein "Der Meister von Messkirch im Lichte der letzten Funde und Forschungen" in Oberrheinische Kunst VI, 1934, p. 93 ff. Plate 20

St. Benedict

Stuttgart, Staatsgalerie

Wood 106×75 cm. Plate 21

Hans Mielich (or Muelich)

1516—1573. School of Munich.

Portrait of the wife of Andreas Liegsalz

Munich, Aeltere Pinakothek

Wood 81×61 cm. With monogram and date 1540. Plate 75

Georg Pencz

c. 1500—1550. Active in Nuremberg and Leipzig. Influenced by Dürer and by Italian Schools.

Portrait of Hans Sigmund von Baldinger

Budapest, Coll. Baron Herczog

The sitter, born in Freising 1510, lived in Ulm from 1529 till his death there in 1558. Plate 19

Jerg Ratgeb

c. 1480—1526. Born in Gmund. Active in Stuttgart, 1509—12 in Heilbronn, 1514—17 in Frankfort, 1518—19 in Herrenberg.

The martyrdom of St. Barbara

Schwaigern, Pfarrkirche

Wood 170×95 cm. With monogram and date 1510. Centre panel from an altarpiece. Plate 30

The Last Supper

Stuttgart, Staatsgalerie

Wood 271×147 cm. Wing of an altarpiece, initialled and dated 1519; from the Stiftskirche in Herrenberg. Plate 31

Ludger Tom Ring the Younger

1522—1584. Westphalian School. Active in Muenster and Brunswick.

Portrait of Huddaeus, priest in Minden

Muenster, Landesmuseum (On loan from Berlin Gallery)

Wood 38.5×29.5 cm. Initialled and dated 1568. Vide Hoelker "Die Malerfamilie Tom Ring", 1927, No. 81. Plate 104

Martin Schaffner

c. 1480—1541. School of Ulm. Pupil of Joerg Stocker (?); also influenced by Burgkmair, Dürer and Schaeufelein.

Portrait of Bernhard Besserer

Ulm, Cathedral

Wood 33.2×23 cm. Plate 90

31

The Annunciation

Munich, Aeltere Pinakothek

Wood 300×158 cm. Dated 1523. Wing of
the High Altar from the Praelaturkirche in
Wettenhausen, founded by the provost
Ulrich Hieber. Reliefs from interior now
in castle of Nuremberg; carved centre piece
in Wettenhausen. Plate 89

Hans Leonard Schaeufelein

Before 1490 — c. 1539. School of Nuremberg;
pupil of Dürer.

Portrait of Sixtus Oelhafen

Würzburg, Kunstgeschichtliches Museum

Wood 43×30 cm. Dated 1519. Plate 16

Abraham Schoepfer (?)

Dates unknown. School of Munich. Follower of
Wolf Huber.

The Resurrection

Basle, Oeffentliche Kunstsammlung

Parchment on Wood 35×24 cm. Dated
1527. This picture was first assigned to
Schoepfer by Buchner vide Beitraege (op. cit.)
I, p. 258 ff. Originally attributed by Amer-
bach to Gruenewald it has been catalogued
by the Basle Gallery as Altdorfer with a
suggested attribution to his pupil The Master
G. Z. who was active in Basle. Plate 68

Tobias Stimmer

1539—1584. Active in Zurich, Schaffhausen and
Strassburg.

Portraits of Jakob Schwytzer of
Zurich and his wife Elsbeth

Basle, Oeffentliche Kunstsammlung

Wood, each panel 191×77 cm. Initialled
and dated 1564. Plate 101

Bernhard Strigel

c. 1460—1528. Active chiefly in Memmingen.
Court painter to the Emperor Maximilian.

Portrait of the Apothecary Wolf-
hardt

German private collection

Wood 45×33 cm. Initialled and dated 1526.
The only known picture signed by this
artist. First seen at exhibition of Early
German Art at Boehler Gallery, Munich
1934. Plate 88

Hans Wertinger
(called Schwabmaler)

Bavarian School. Died 1533. Active in Landshut
after 1491 at the Courts of George the Rich and
Ludwig X.

December

Nuremberg, Germanisches Nationalmuseum

Wood 34×41.5 cm. One of a series of
Months of the Year. Plate 76

Wolf Traut

Pupil of Dürer. Died in Nuremberg 1520.

Artelshofen Altarpiece

Munich, Bayrisches Museum

Wood; centre panel 168×114 cm; wings
168×46 cm. Originally donated by Kunz
Horn for the Tuchmacherkapelle of the
Church of St. Lawrence in Nuremberg.

 Plate 17

Illustrations

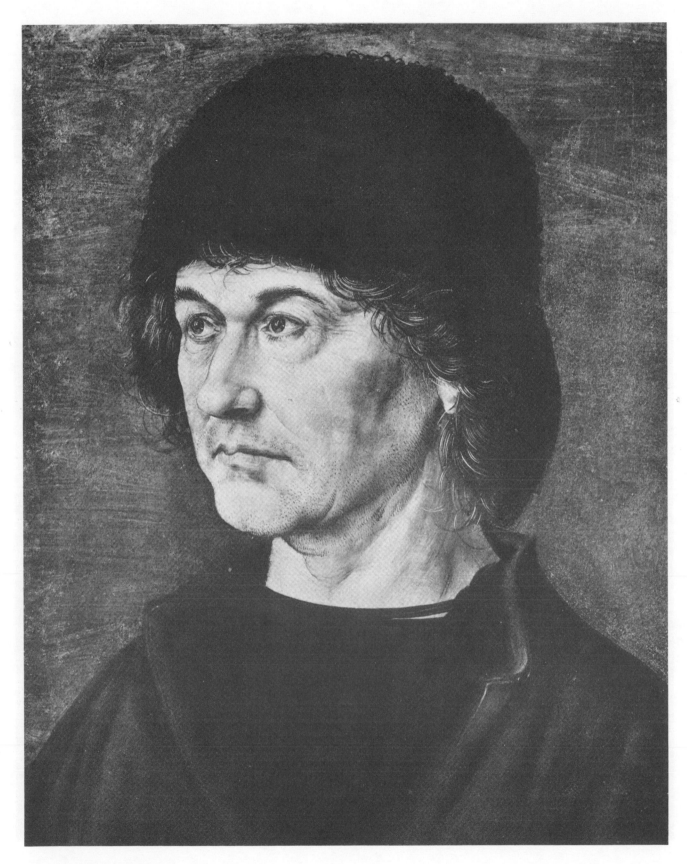

1 ALBRECHT DÜRER

Portrait of his father (Detail)
Florence, Uffizi

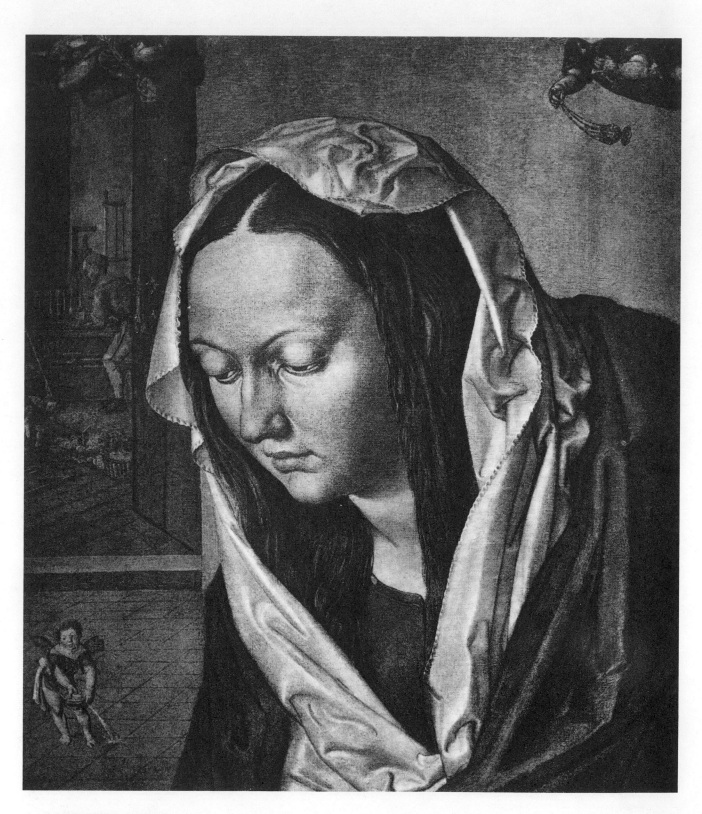

2 **ALBRECHT DÜRER**
 The Madonna and Child (centre panel from
 Dresden Altarpiece, Detail)
 Dresden, Gemaeldegalerie

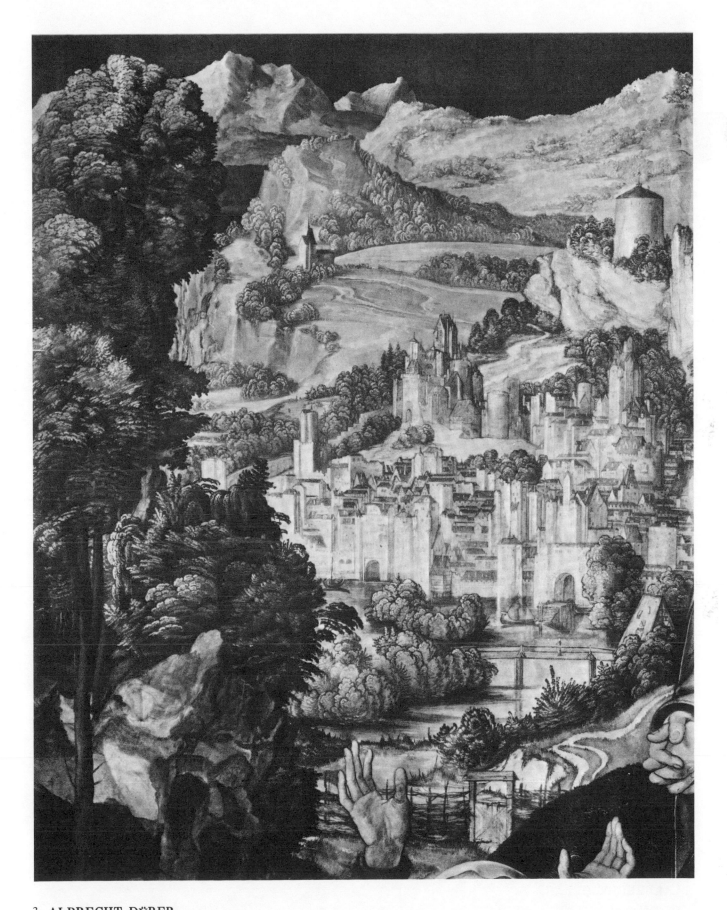

3 **ALBRECHT DÜRER**
The lamentation over the Dead Christ (Detail)
Munich, Aeltere Pinakothek

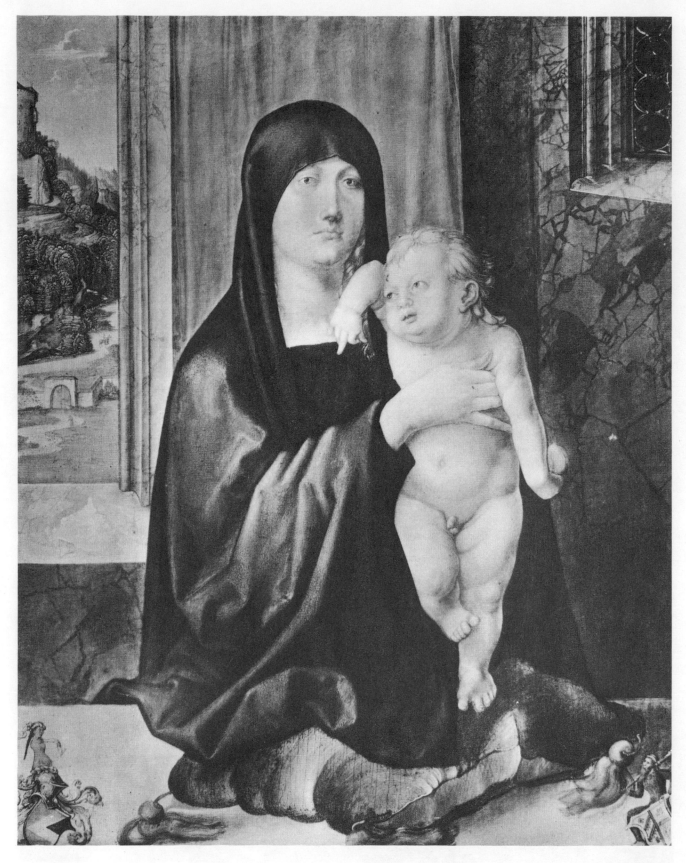

4 ALBRECHT DÜRER
The Madonna and Child
Lugano, Coll. Baron Thyssen-Bornemisza

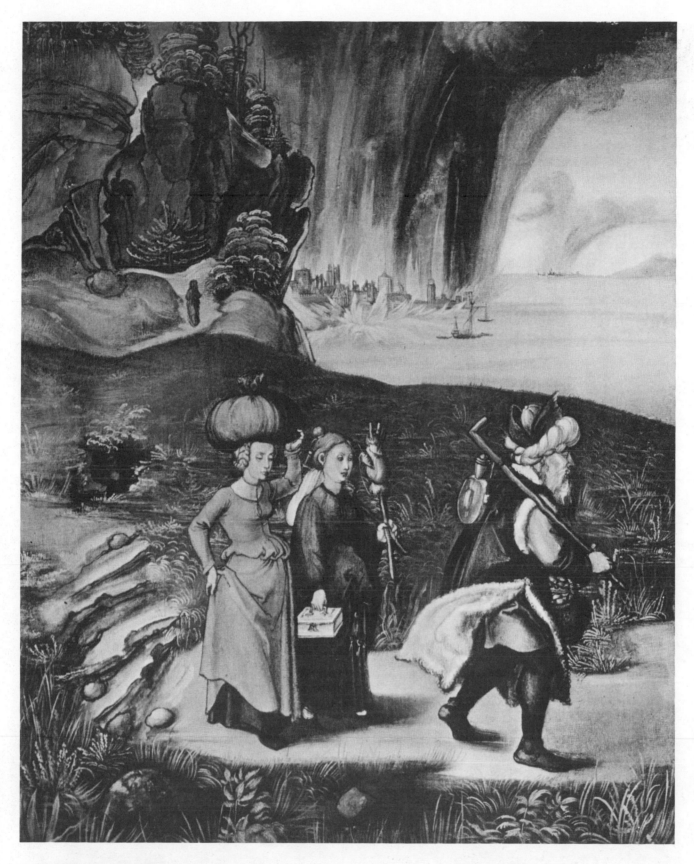

5 ALBRECHT DÜRER

The Flight of Lot with his daughters; (reverse of
the above)
Lugano, Coll. Baron Thyssen-Bornemisza

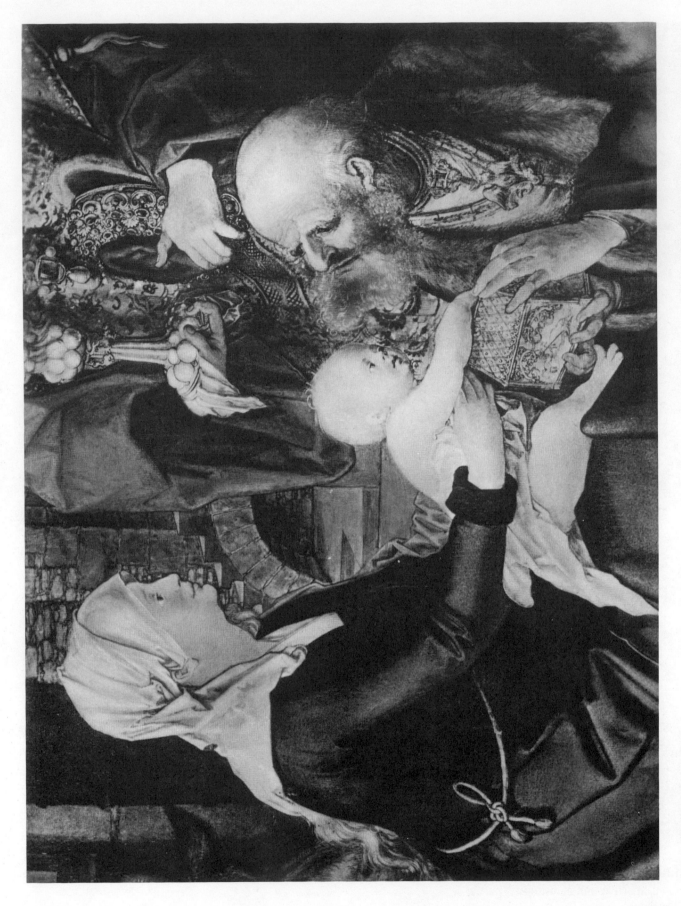

6 **ALBRECHT DÜRER**

The Adoration of the Kings (Detail)
Florence, Uffizi

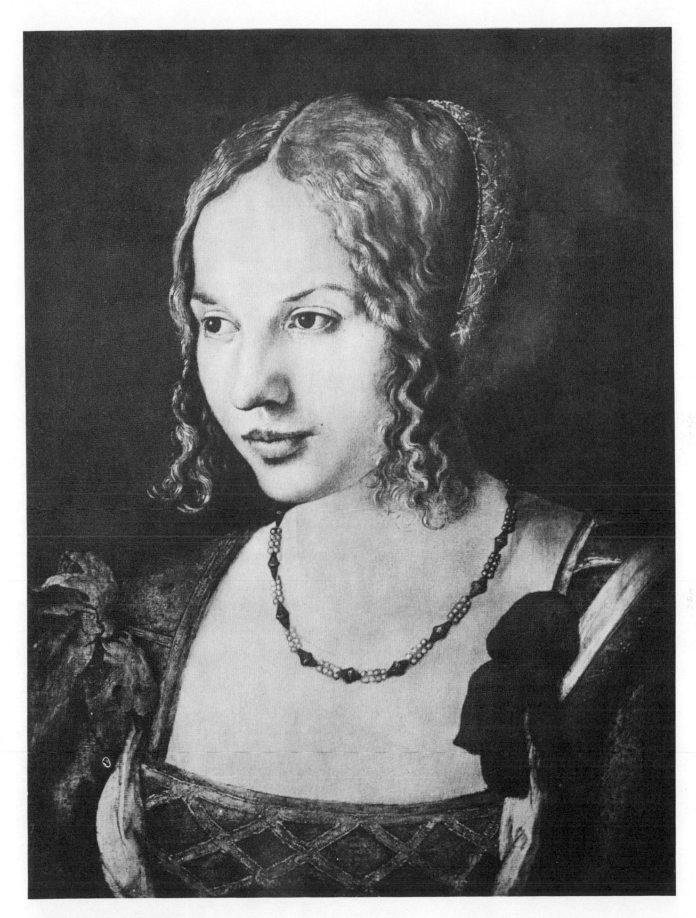

7 **ALBRECHT DÜRER**
 Portrait of a Venetian Lady
 Vienna, Kunsthistorisches Museum

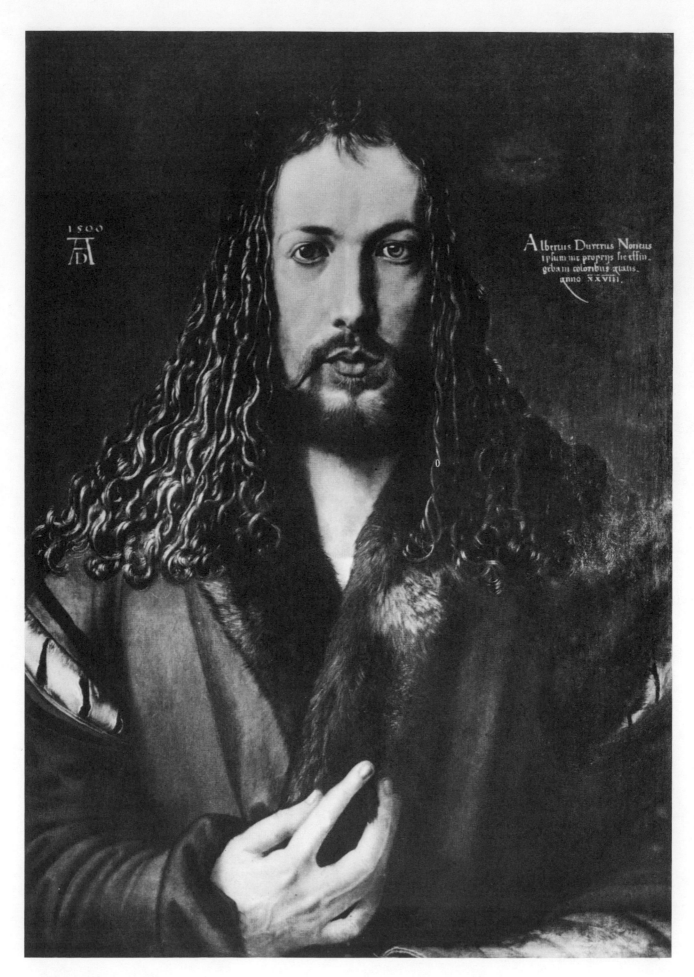

8 ALBRECHT DÜRER
Self-Portrait
Munich, Aeltere Pinakothek

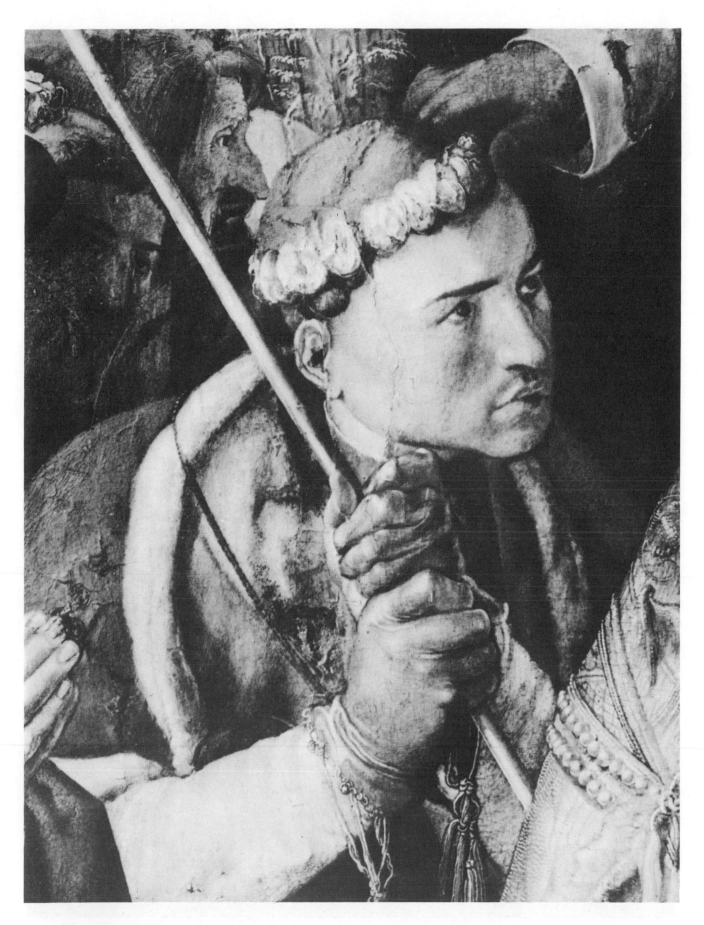

9 ALBRECHT DÜRER

The Madonna of the Crowns of Roses
Prague, Gemaeldegalerie

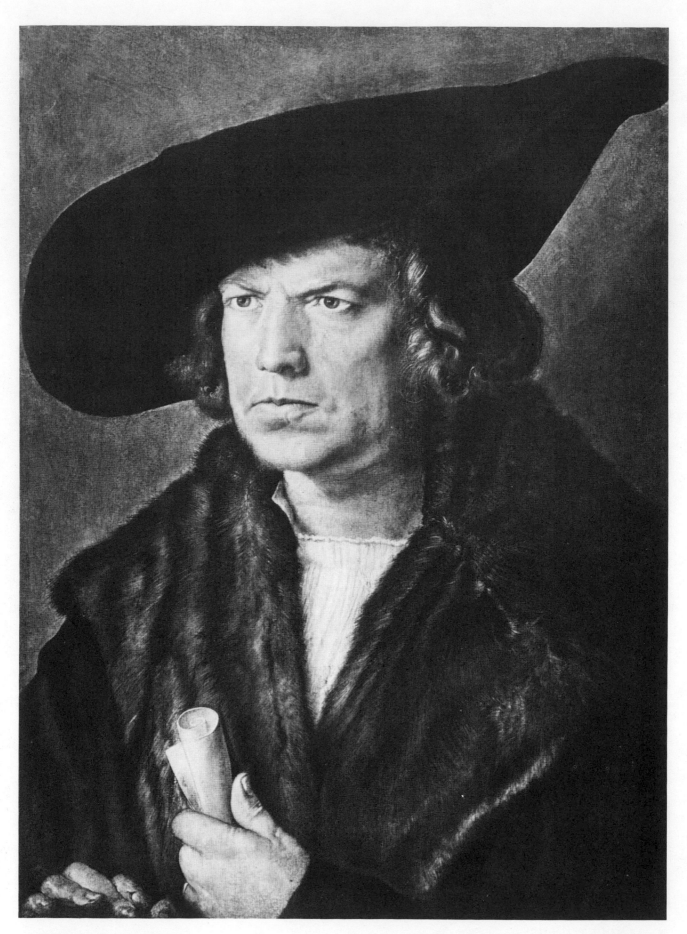

10 ALBRECHT DÜRER
 Portrait of Willibald Pirckheimer
 Madrid, Prado

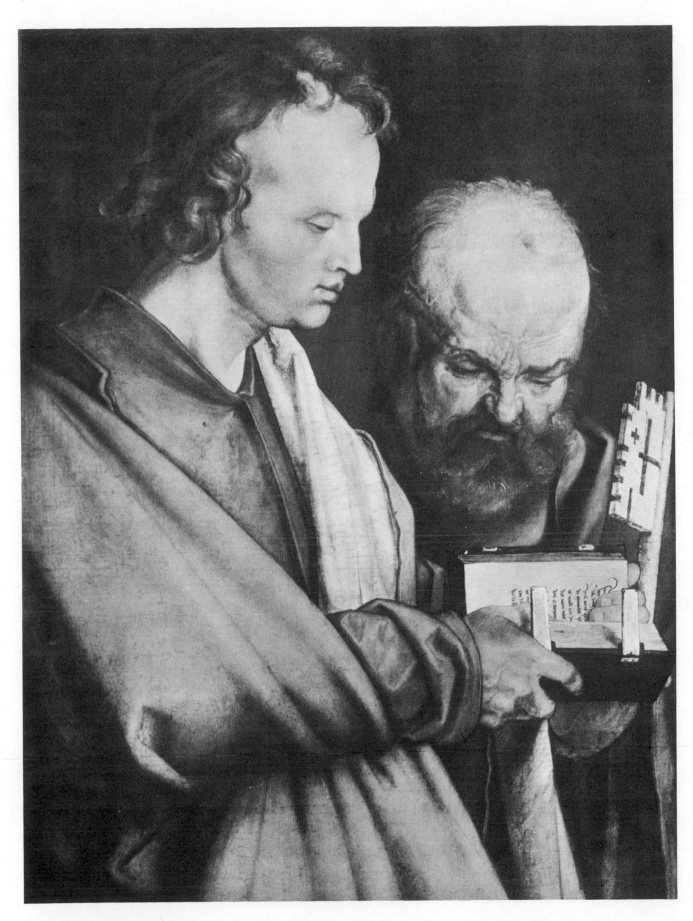

11 ALBRECHT DÜRER
The Four Apostles (Detail)
Munich, Aeltere Pinakothek

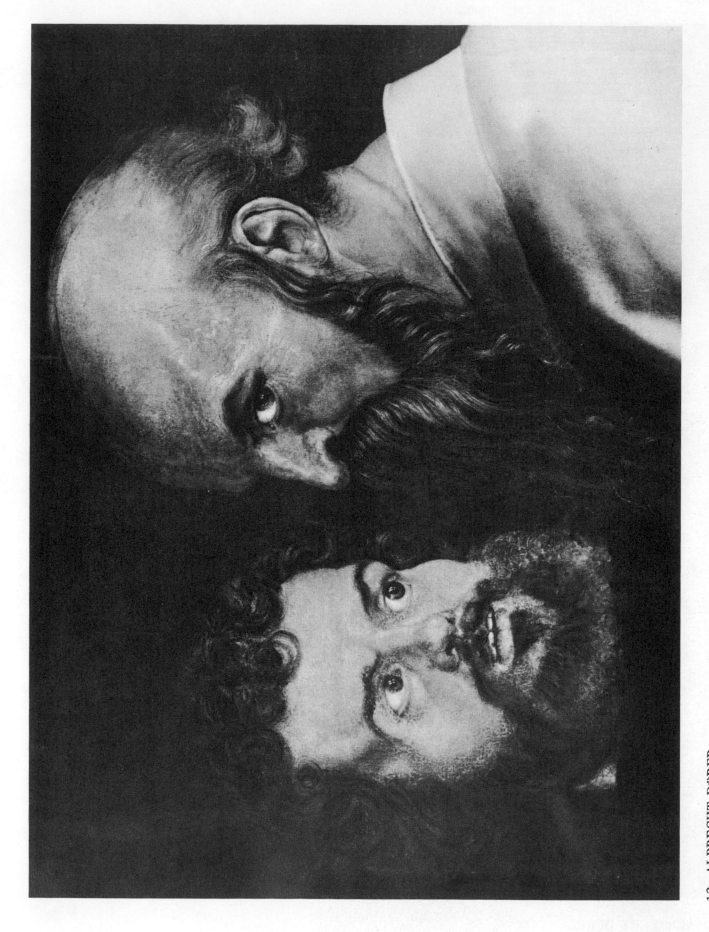

12 ALBRECHT DÜRER

The Four Apostles (Detail)
Munich, Aeltere Pinakothek

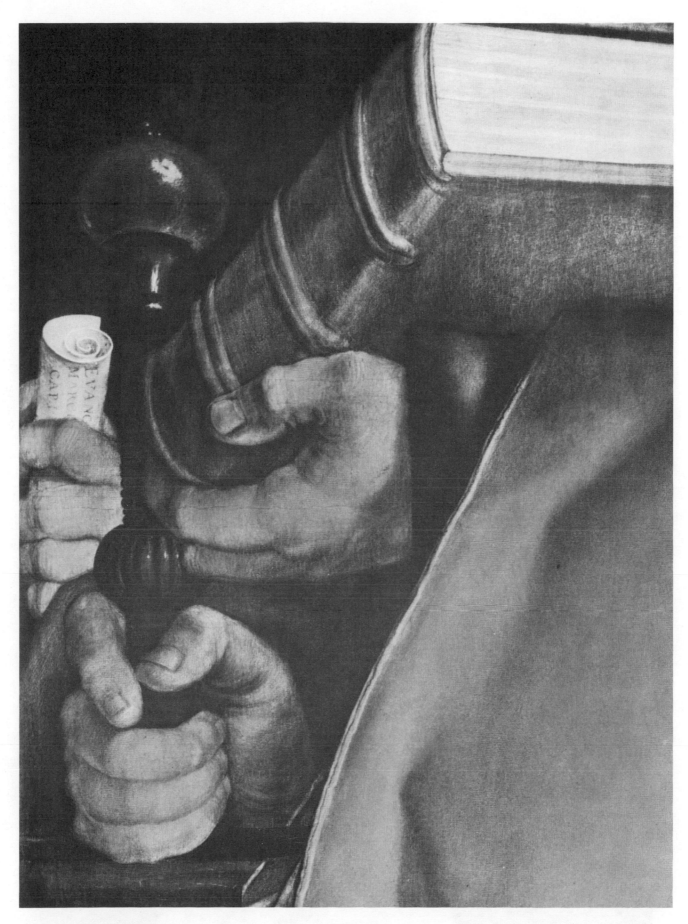

13 **ALBRECHT DÜRER**

The Four Apostles (Detail)
Munich, Aeltere Pinakothek

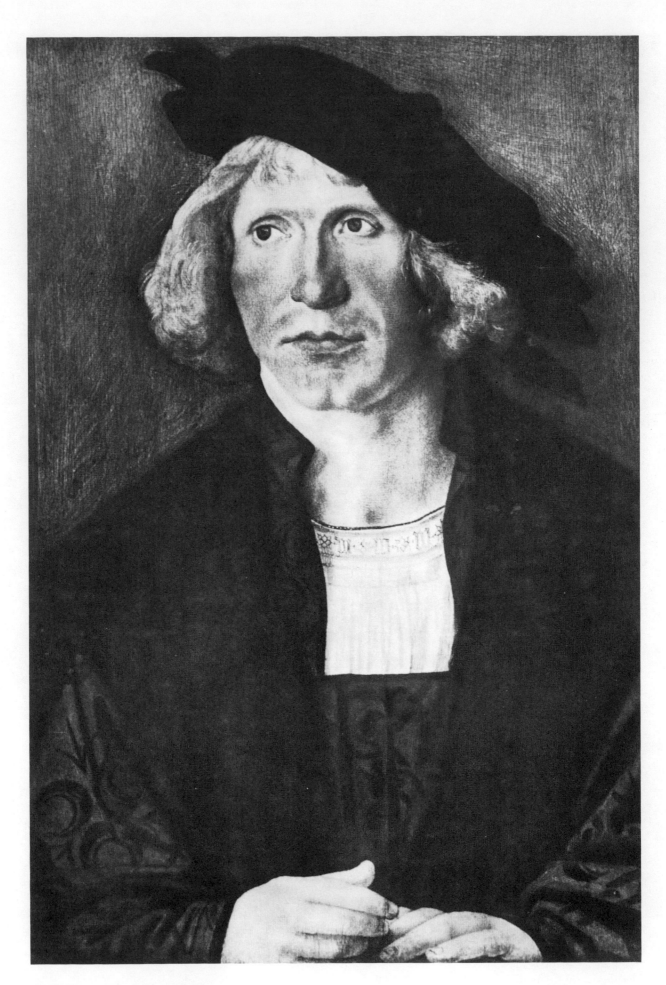

14 **HANS VON KULMBACH**

Portrait of a man
Nuremberg, Germanisches Nationalmuseum

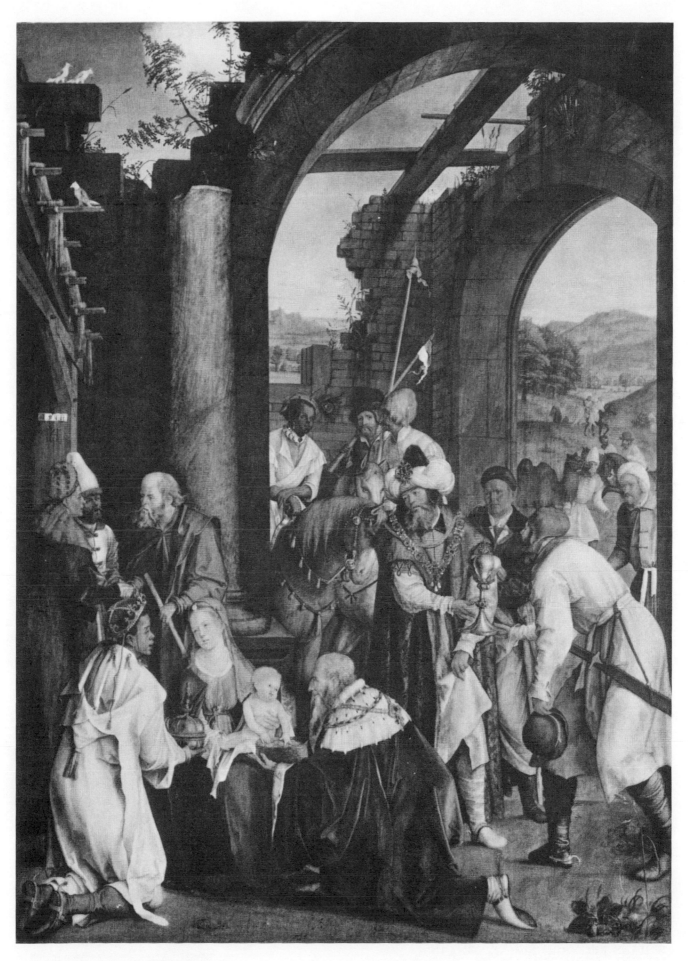

15 HANS VON KULMBACH

The Adoration of the Kings
Berlin, Deutsches Museum

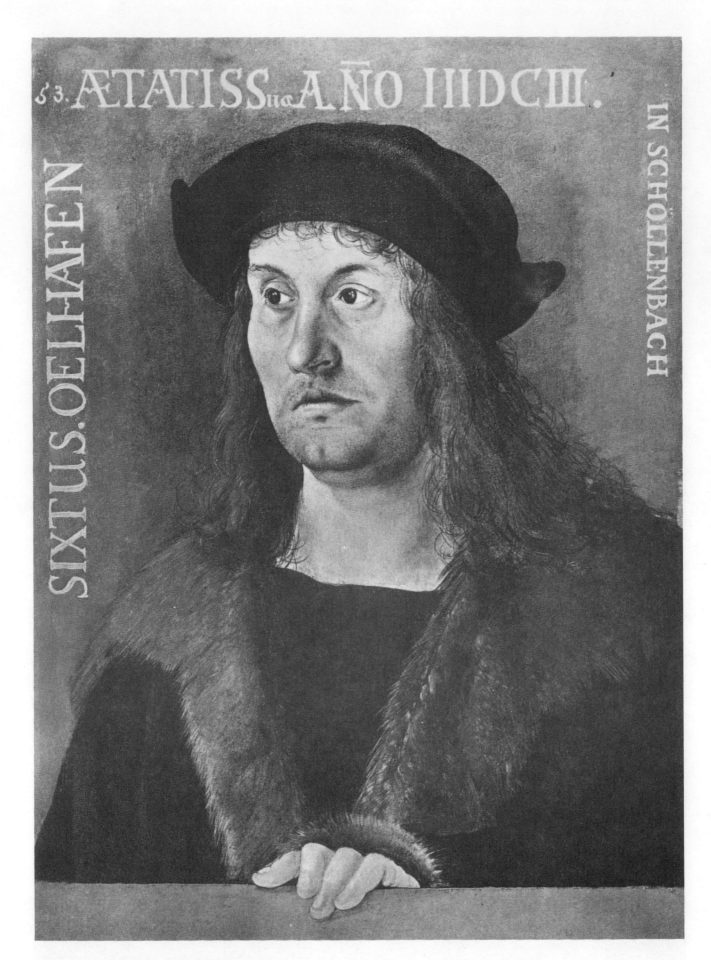

16 HANS LEONARD SCHAEUFELEIN

Portrait of Sixtus Oelhafen
Wuerzburg, Kunstgeschichtliches Museum

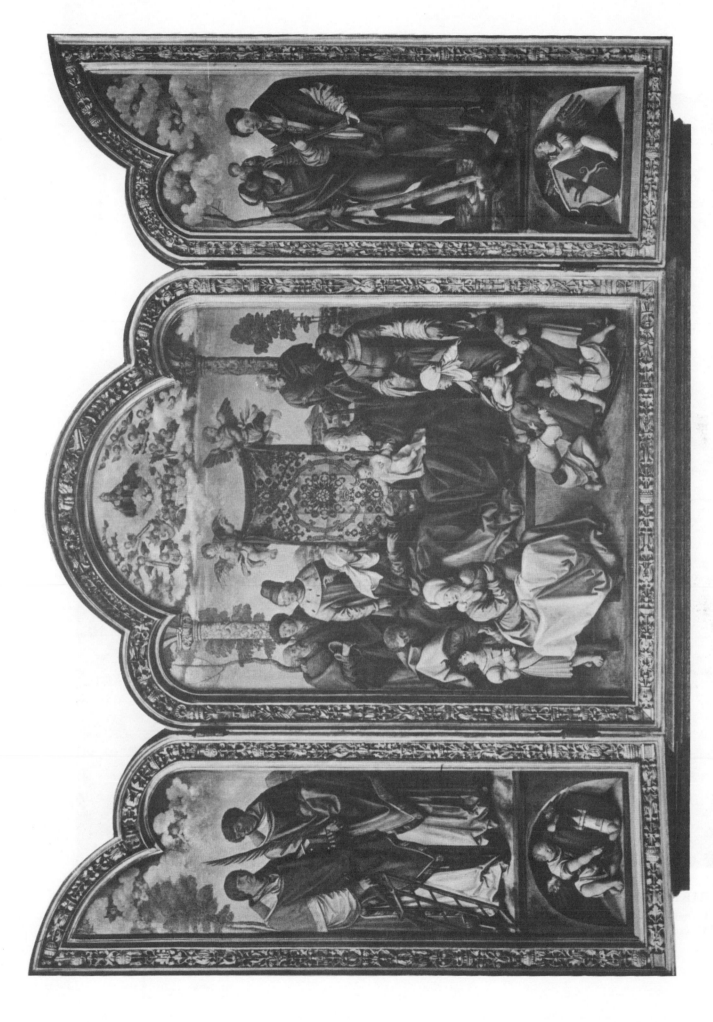

17 **WOLF TRAUT**

Artelshofen Altarpiece
Munich, Bayrisches National Museum

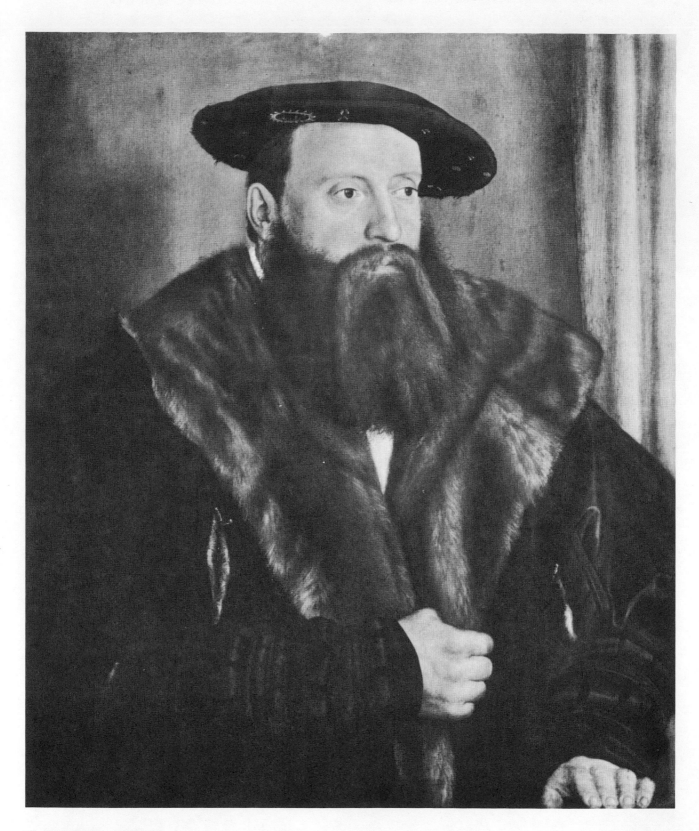

18 BARTHEL BEHAM
 Portrait of Ludwig X of Bavaria
 Vienna, Liechtenstein Gallery

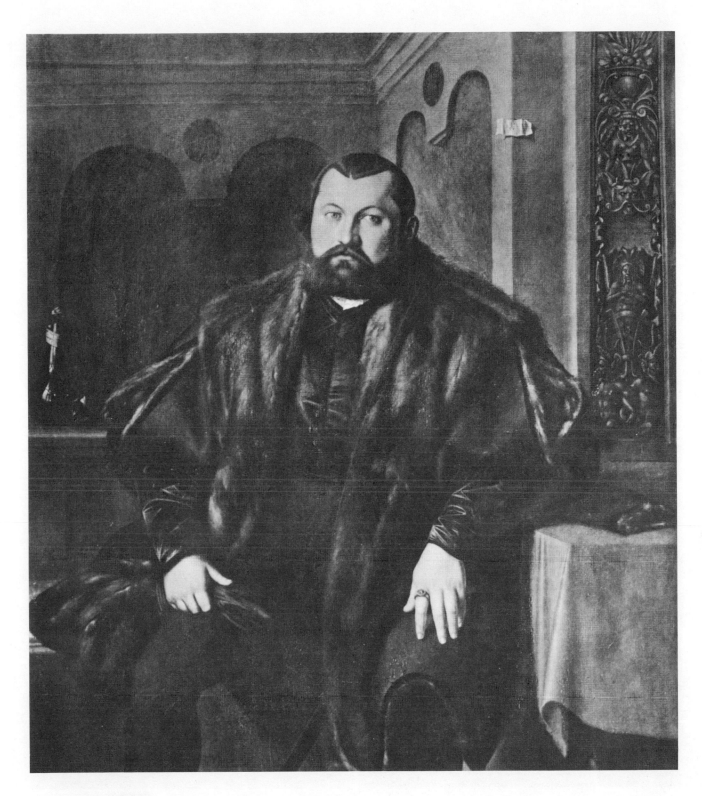

19 **GEORG PENCZ**
 Portrait of Hans Sigmund v. Baldinger
 Budapest, Coll. Baron Herczog †

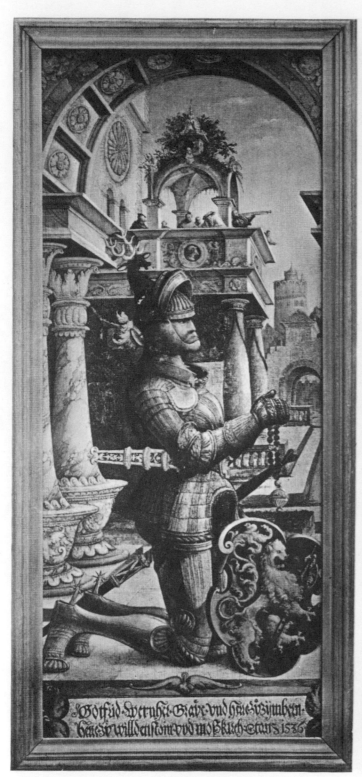
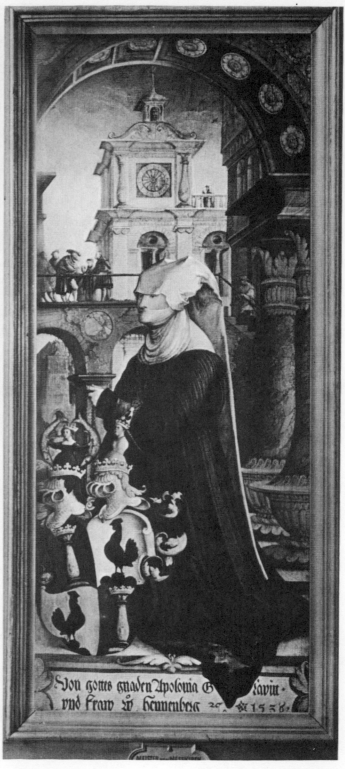

20 THE MASTER OF MESSKIRCH
Portraits of Graf Gottfried Werner and Graefin
Apollonia von Zimmern
Donaueschingen, Galerie

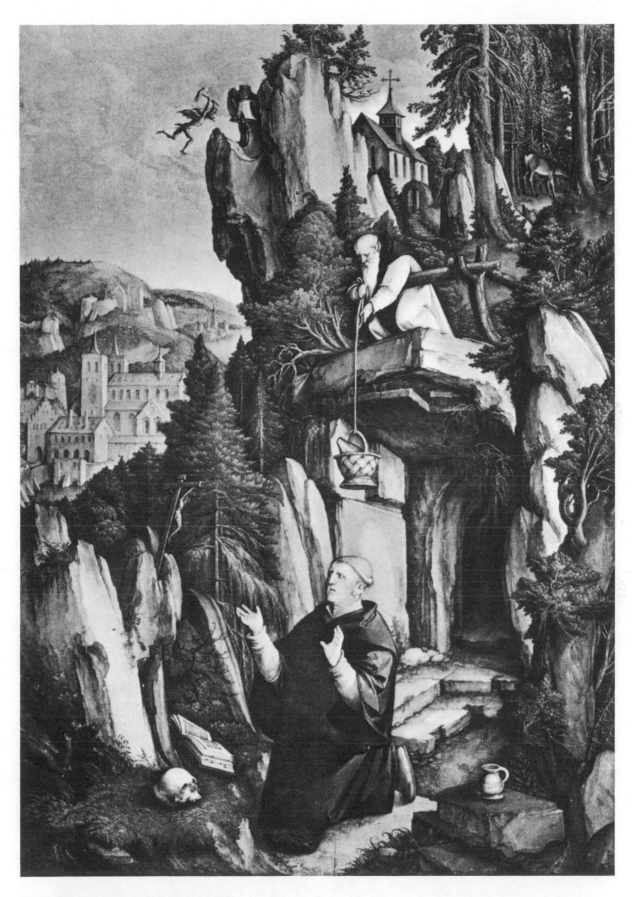

21 THE MASTER OF MESSKIRCH
St. Benedict
Stuttgart, Staatsgalerie

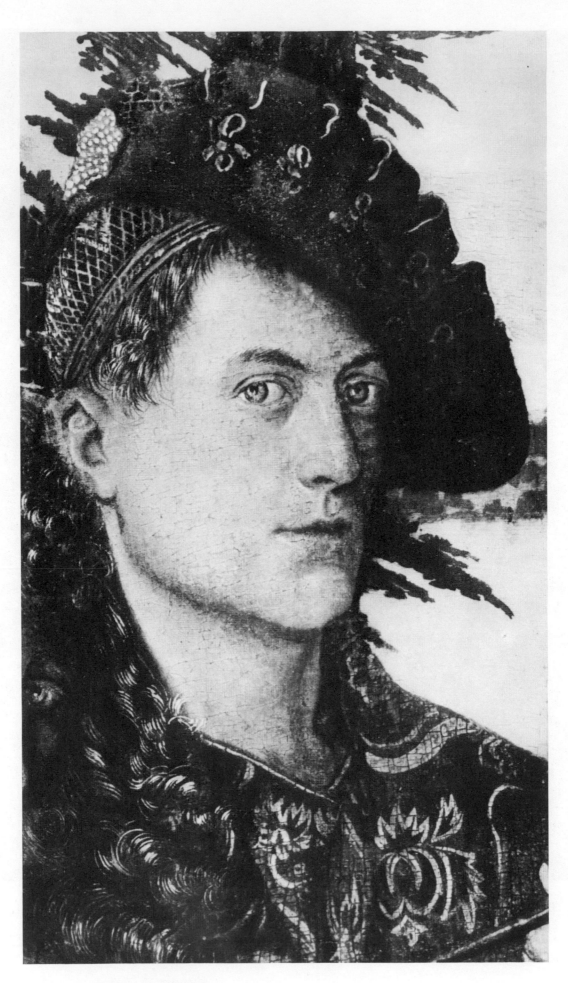

22 HANS BALDUNG GRIEN
 Self-Portrait (Detail from the Sebastian Altarpiece)
 Nuremberg, Germanisches Nationalmuseum

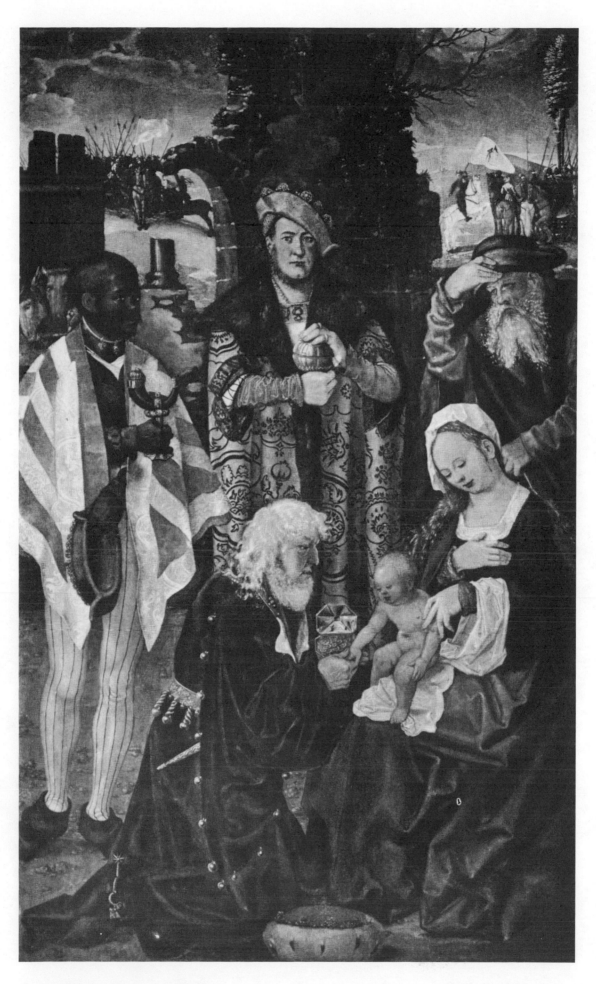

23 HANS BALDUNG GRIEN

The Adoration of the Kings
Berlin, Deutsches Museum

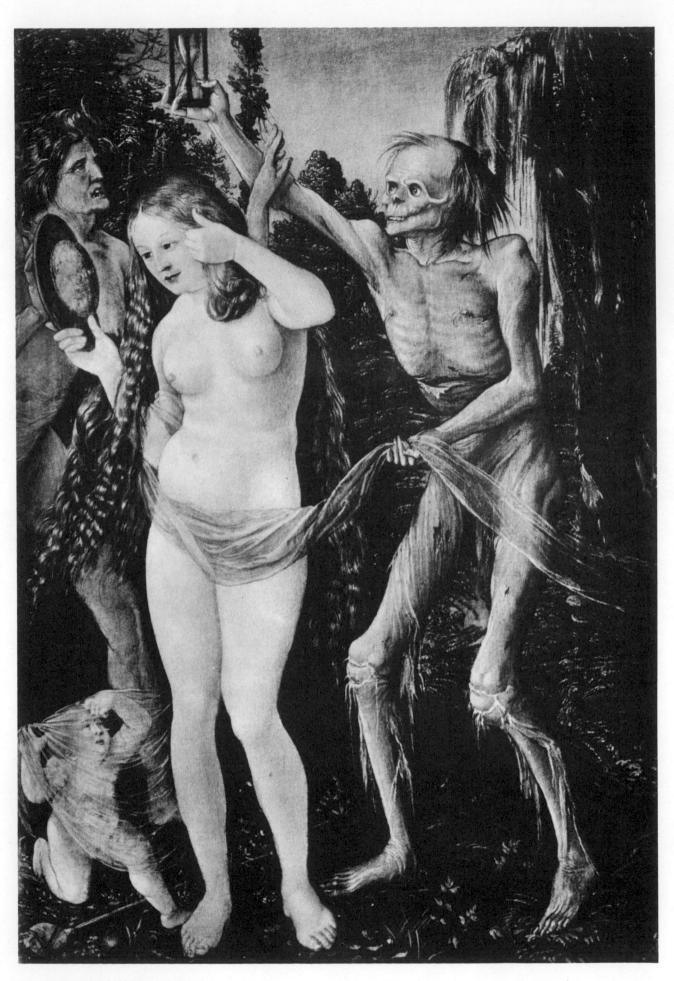

24 HANS BALDUNG GRIEN
The Allegory of Vanity
Vienna, Kunsthistorisches Museum

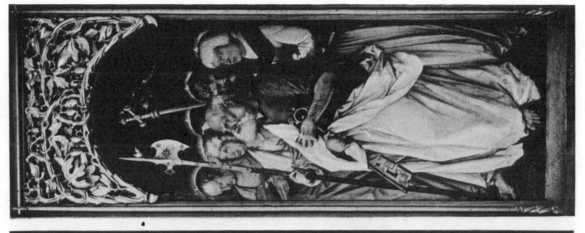

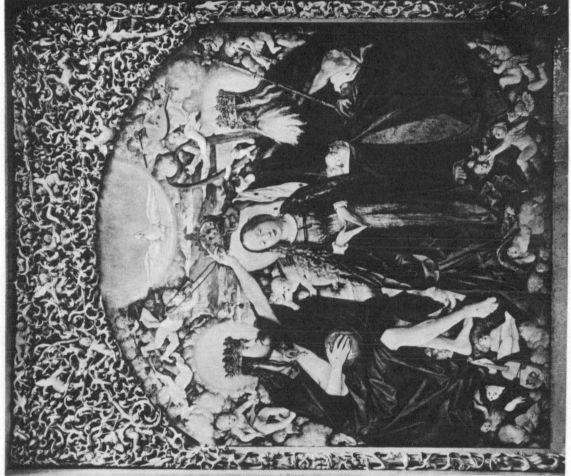

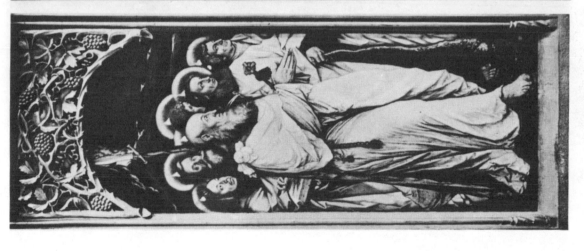

25 HANS BALDUNG GRIEN
The Coronation of The Virgin
Freiburg, Cathedral

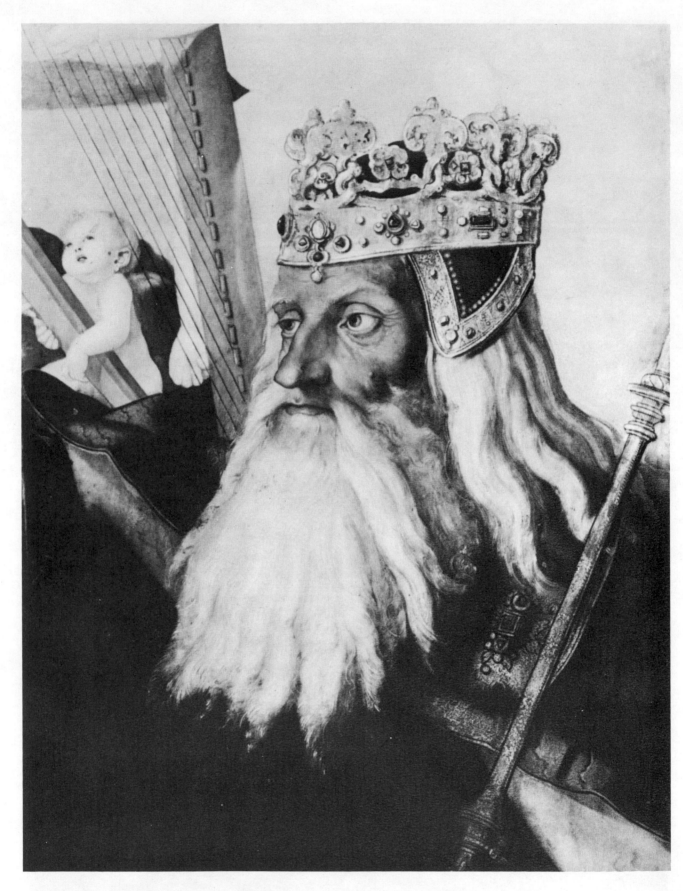

26 HANS BALDUNG GRIEN
 The Head of God The Father (Detail from Pl. 25)
 Freiburg, Cathedral

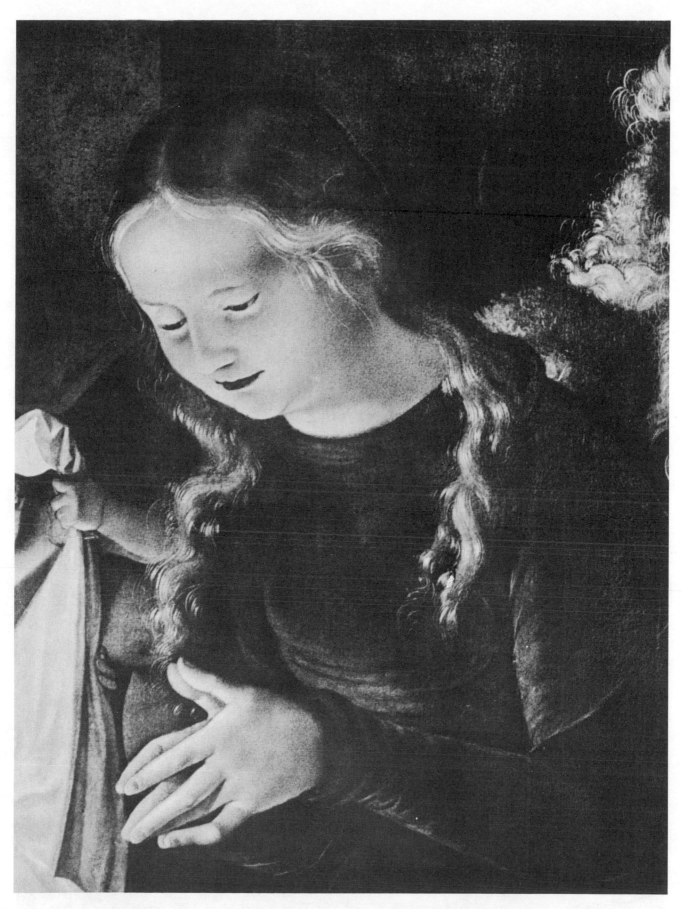

27 HANS BALDUNG GRIEN

The Nativity (Detail)
Freiburg, Cathedral

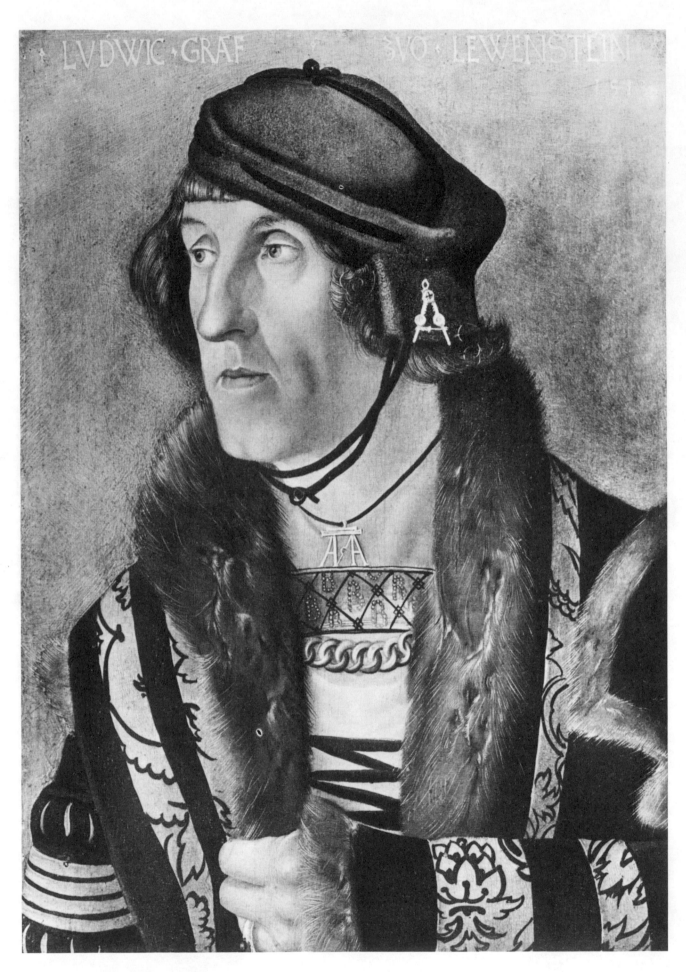

28 HANS BALDUNG GRIEN
Portrait of Graf von Loewenstein
Berlin, Deutsches Museum

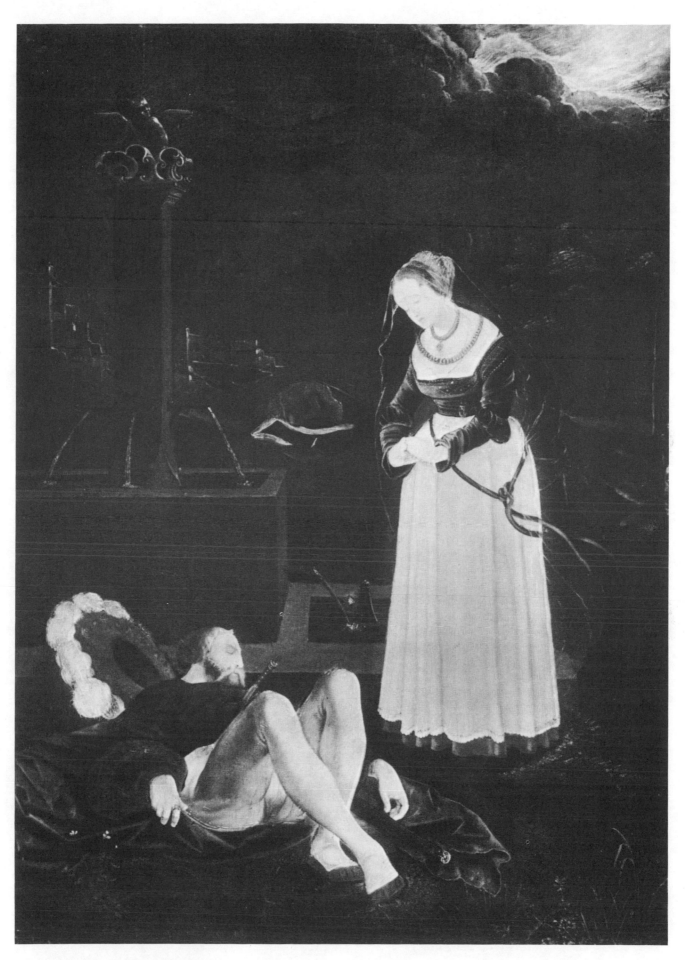

29 HANS BALDUNG GRIEN

Pyramus and Thisbe
Berlin, Deutsches Museum

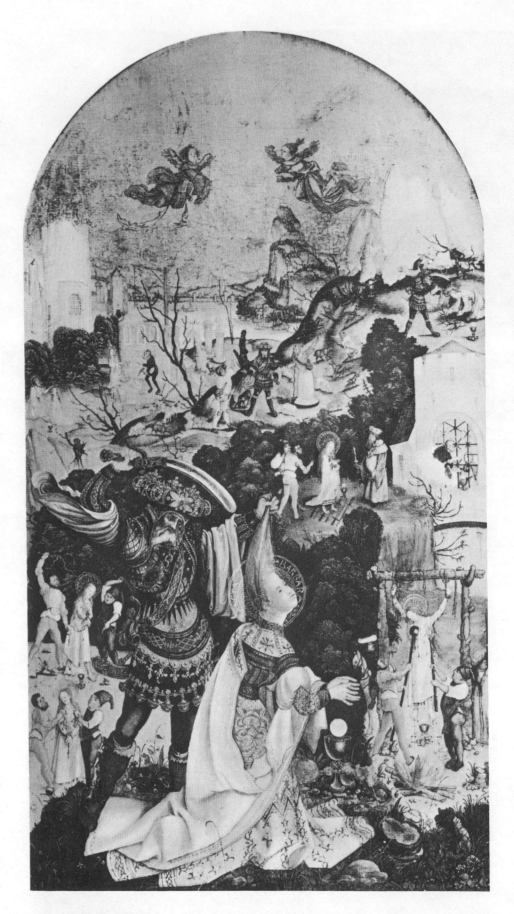

30 **JERG RATGEB**

The Martyrdom of St. Barbara
Schwaigern, Pfarrkirche

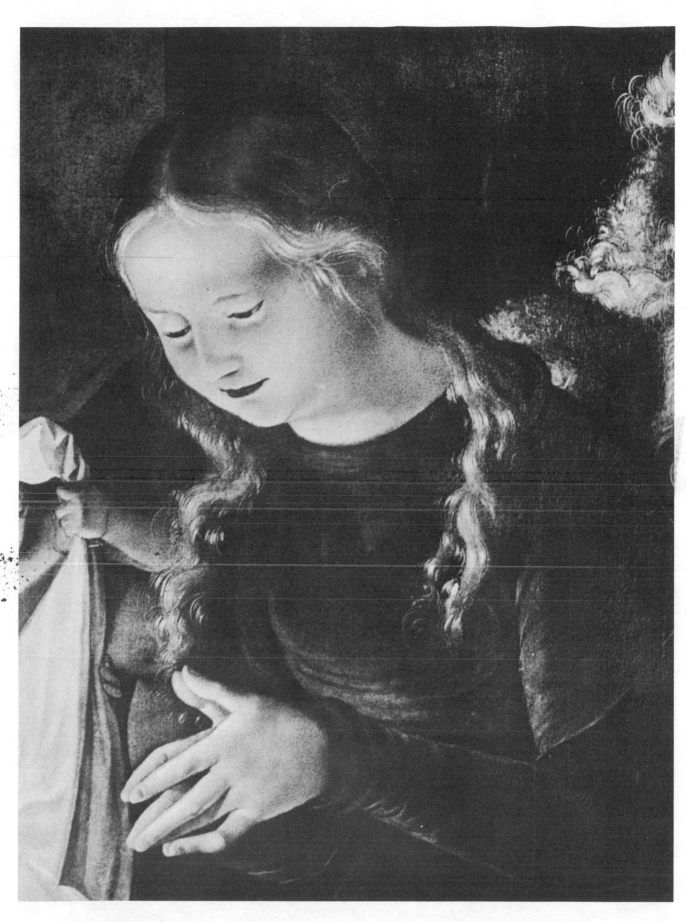

27 HANS BALDUNG GRIEN
The Nativity (Detail)
Freiburg, Cathedral

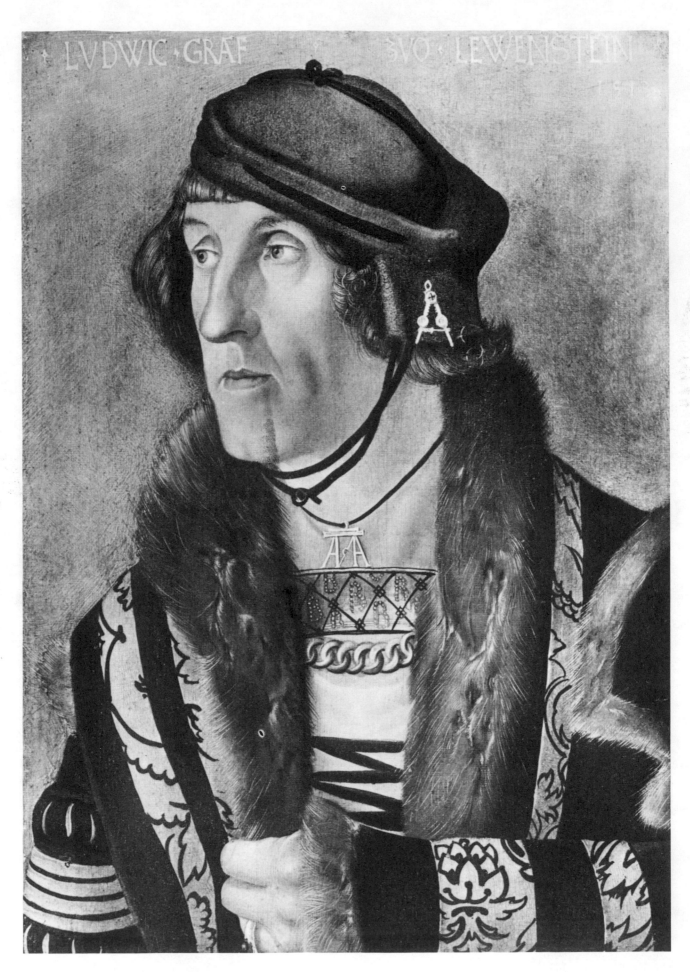

28 HANS BALDUNG GRIEN

Portrait of Graf von Loewenstein
Berlin, Deutsches Museum

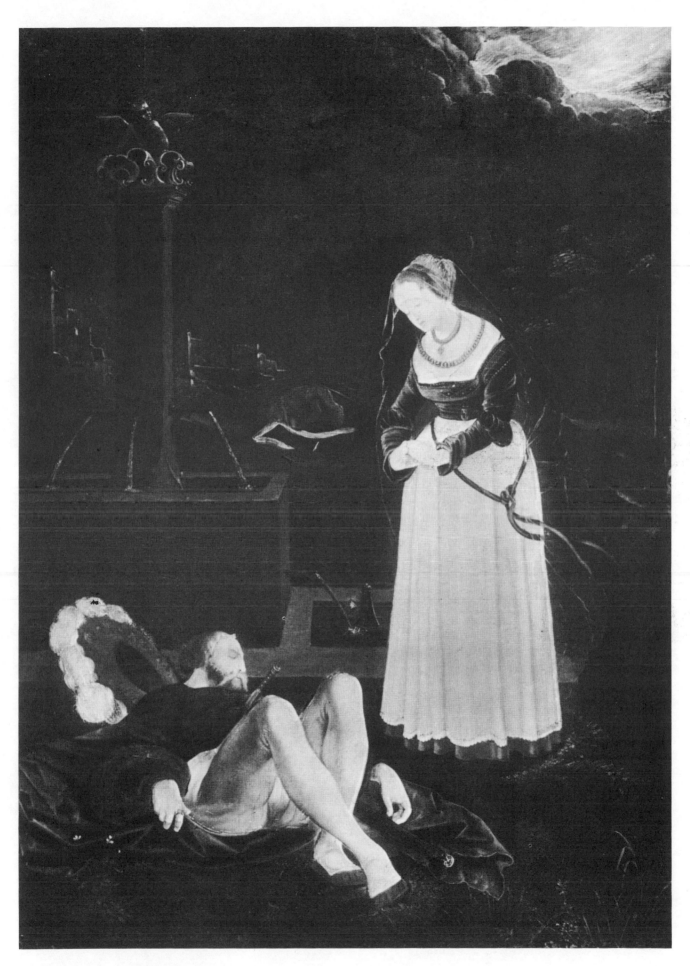

29 HANS BALDUNG GRIEN
Pyramus and Thisbe
Berlin, Deutsches Museum

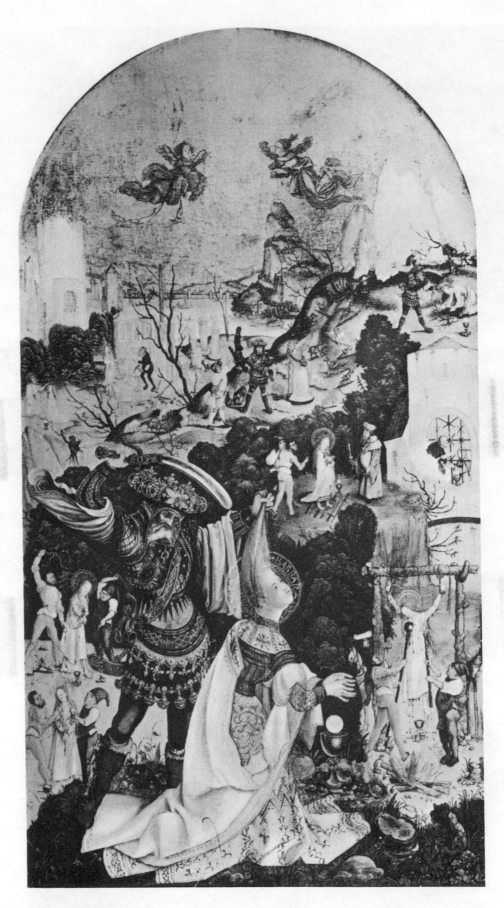

30 JERG RATGEB

The Martyrdom of St. Barbara
Schwaigern, Pfarrkirche

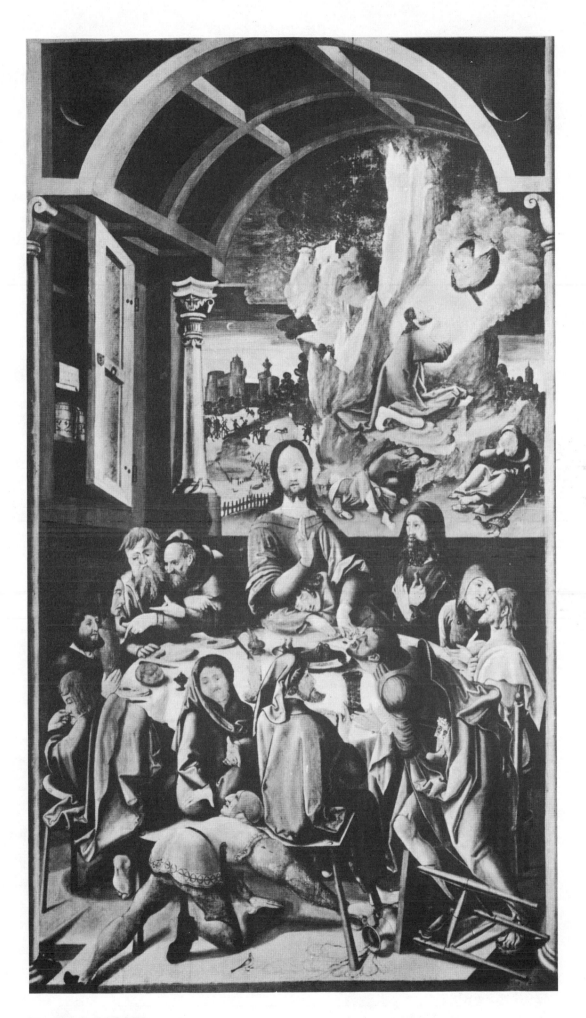

31 JERG RATGEB

The Last Supper
Stuttgart, Staatsgalerie

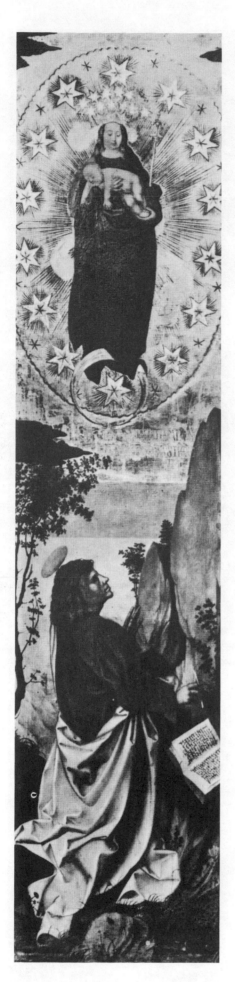
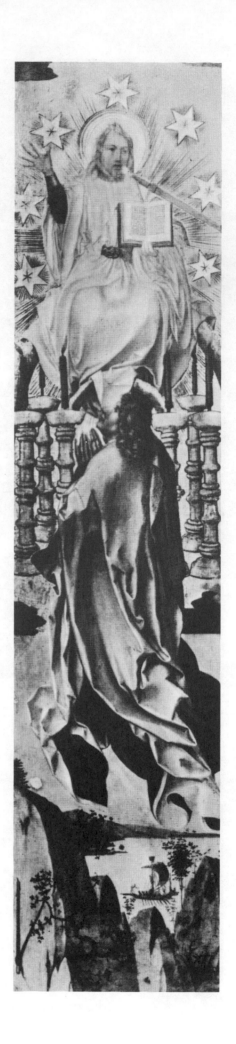

32 HANS FRIES

Two Visions of St. John the Divine
Zurich, Schweizerisches Landesmuseum

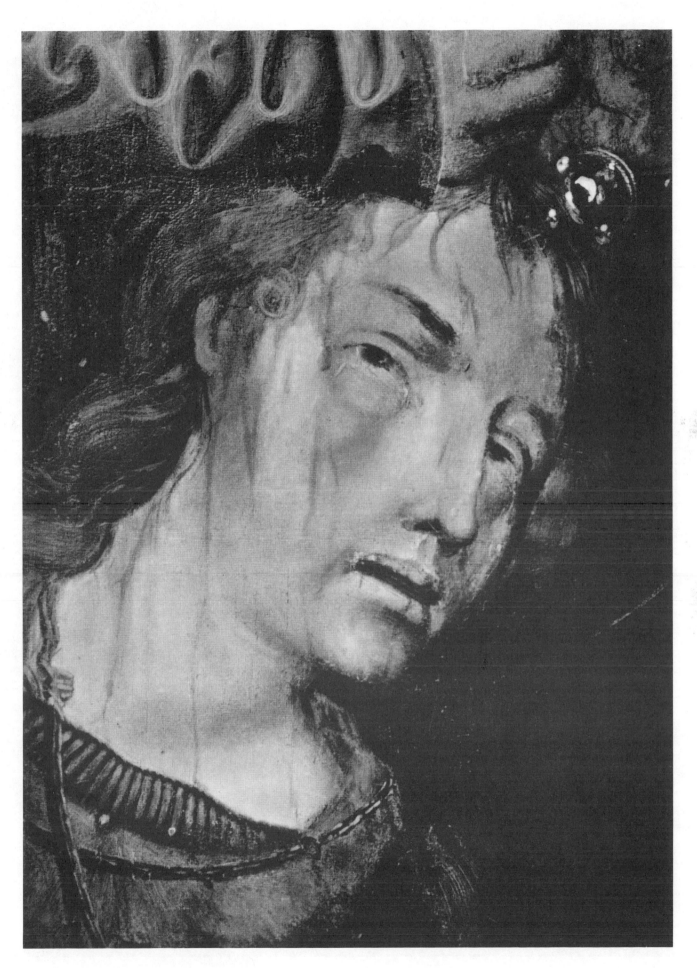

33 HANS FRIES
The Martyrdom of St. Barbara (Detail)
Freiburg, Museum

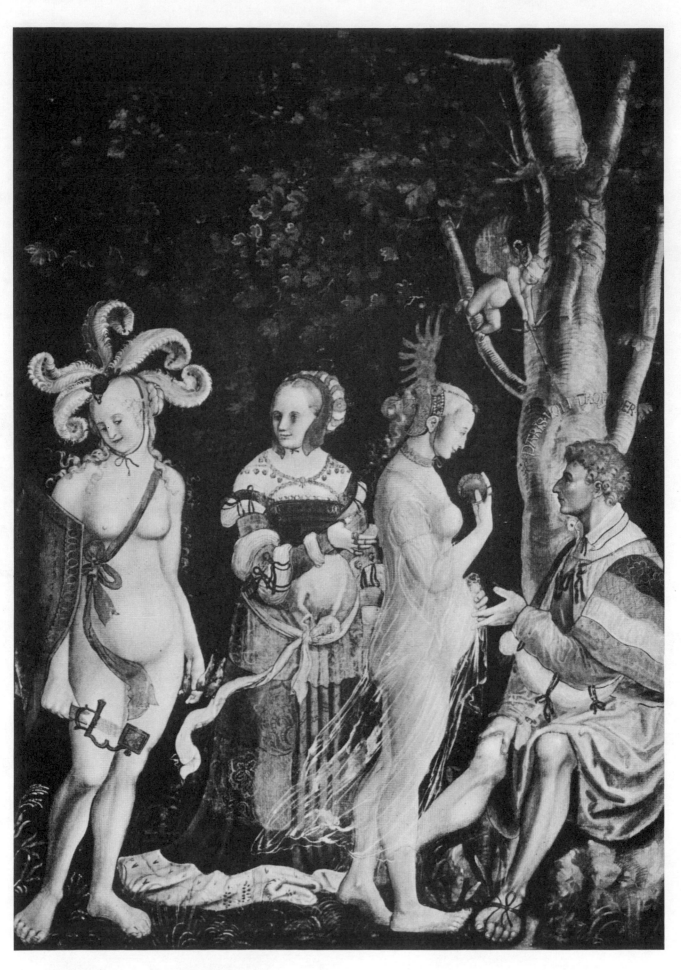

34 NIKLAUS MANUEL called DEUTSCH

The Judgment of Paris
Basle, Oeffentliche Kunstsammlung

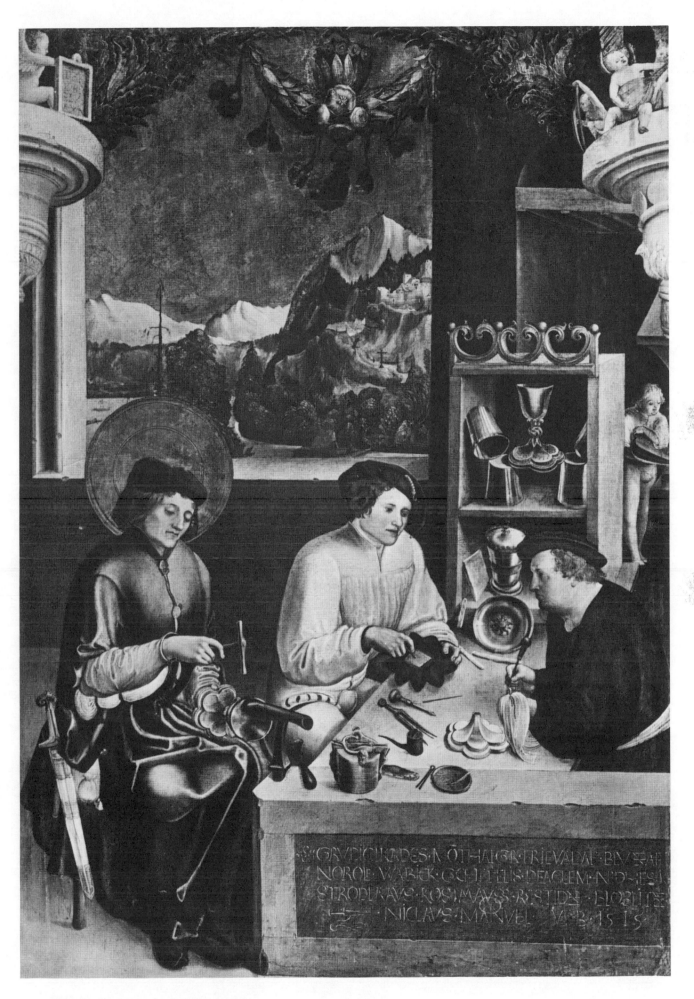

35 NIKLAUS MANUEL called DEUTSCH

The Workshop of St. Eloy
Sarasota, John G. Ringling Museum

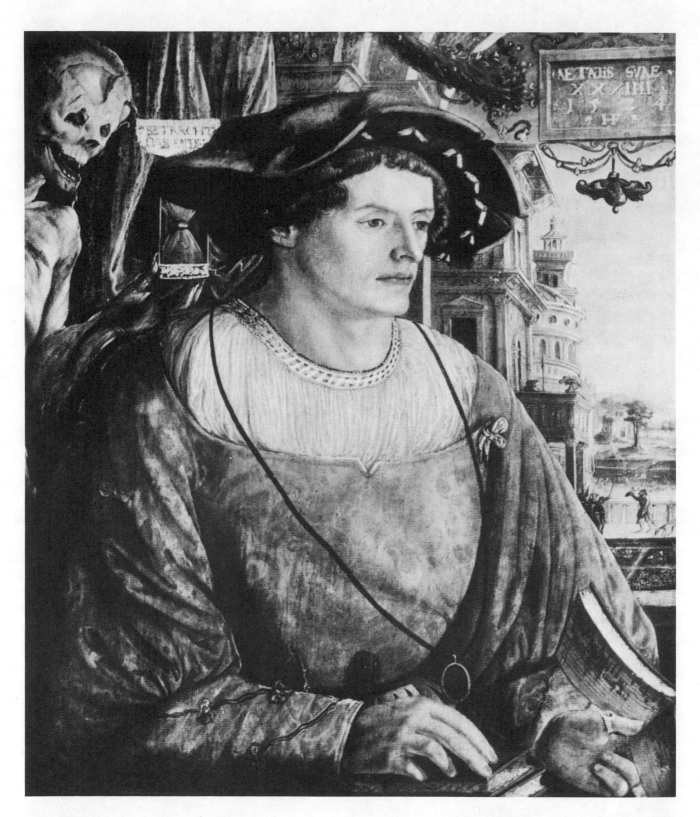

36 HANS FUNK

Portrait of a man
Vienna, Akademie der bildenden Kuenste

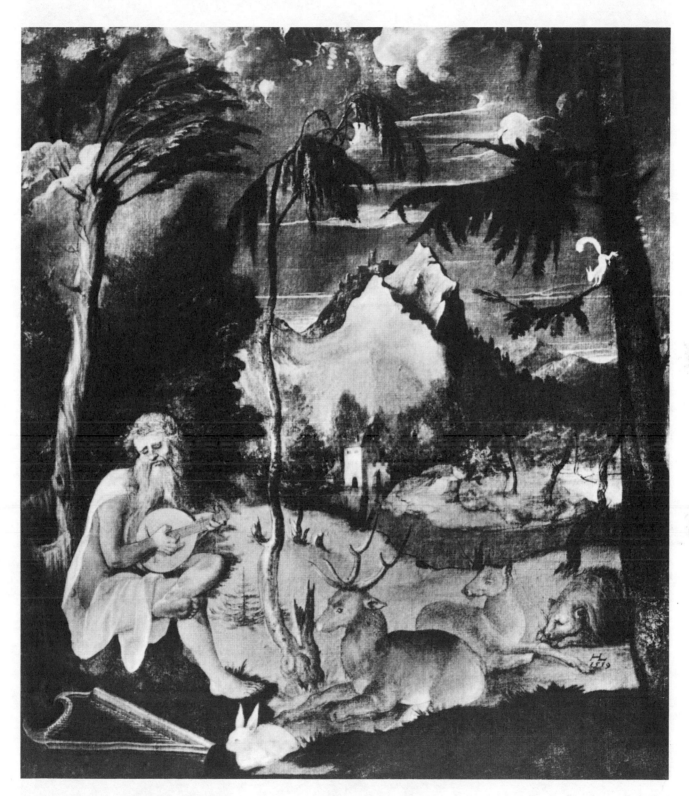

37 HANS LEU THE YOUNGER

Orpheus and the animals
Basle, Oeffentliche Kunstsammlung

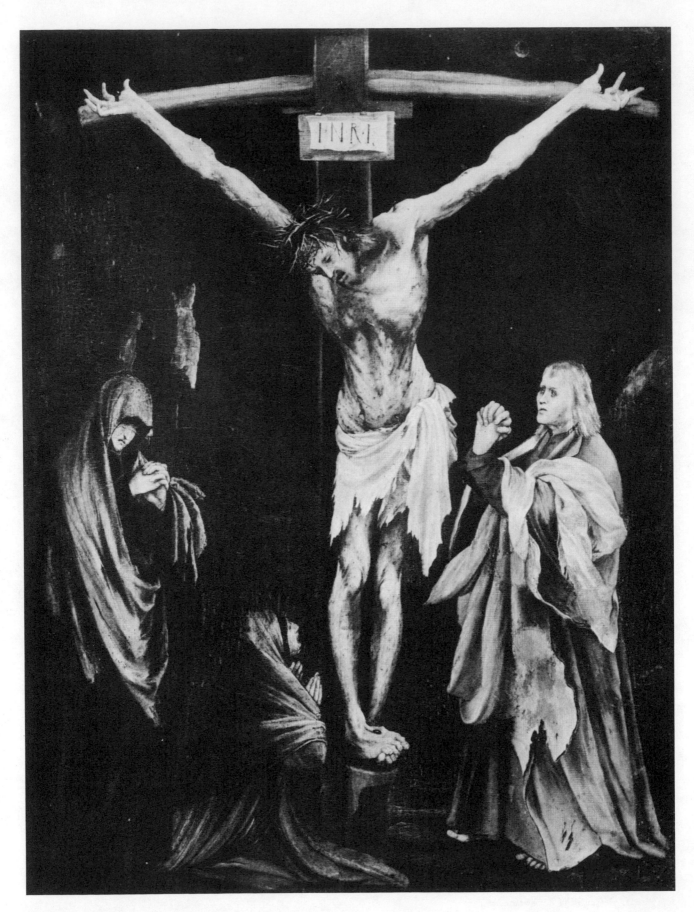

38 GRUENEWALD

The Crucifixion
Haarlem, Coll. Koenig

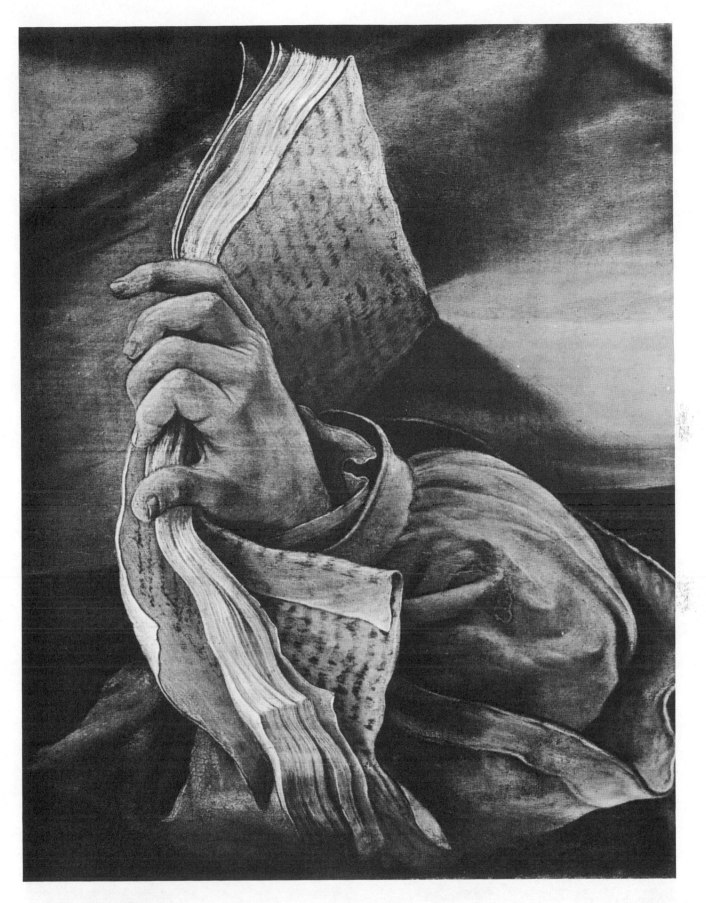

39 GRUENEWALD

St. Lawrence (Detail)
Frankfort on Main, Staedel Institute

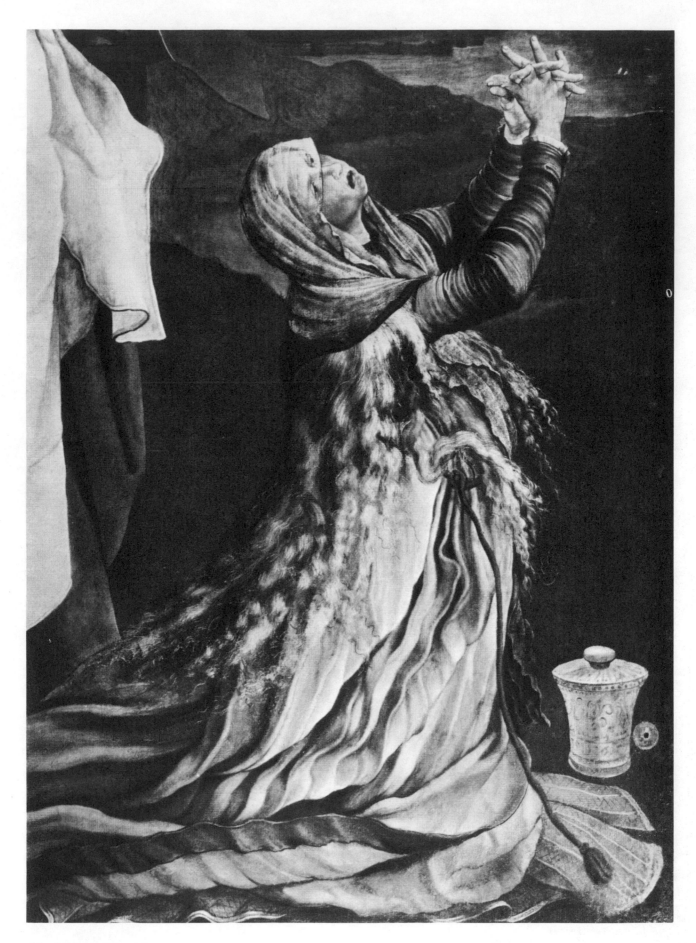

40 GRUENEWALD

The Weeping Magdalen (Detail from the Isen-
heim Altarpiece)
Colmar, Museum Unterlinden

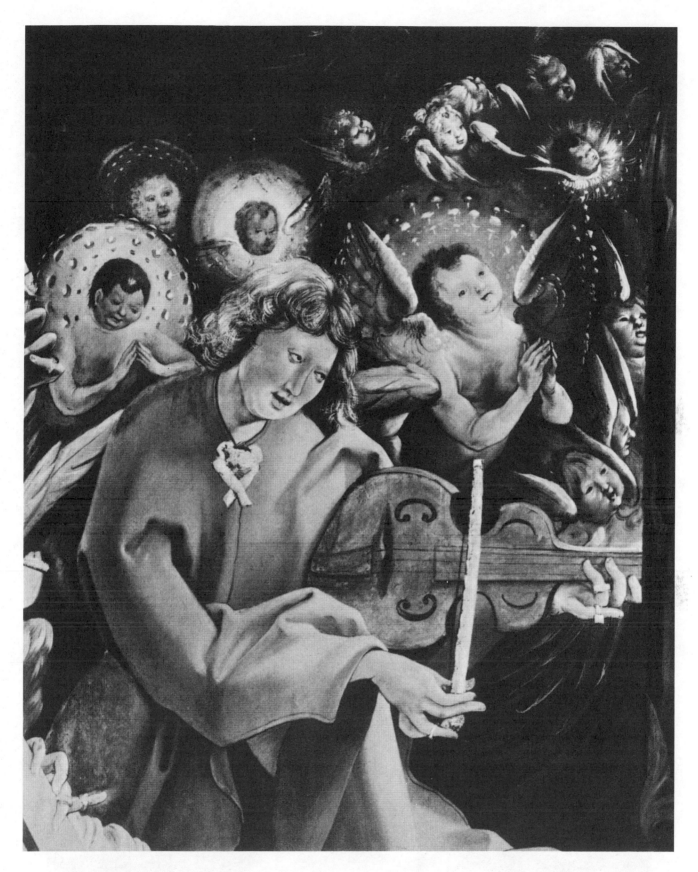

41 **GRUENEWALD**

Angel Musicians (Detail from the Isenheim Altar-
piece)
Colmar, Museum Unterlinden

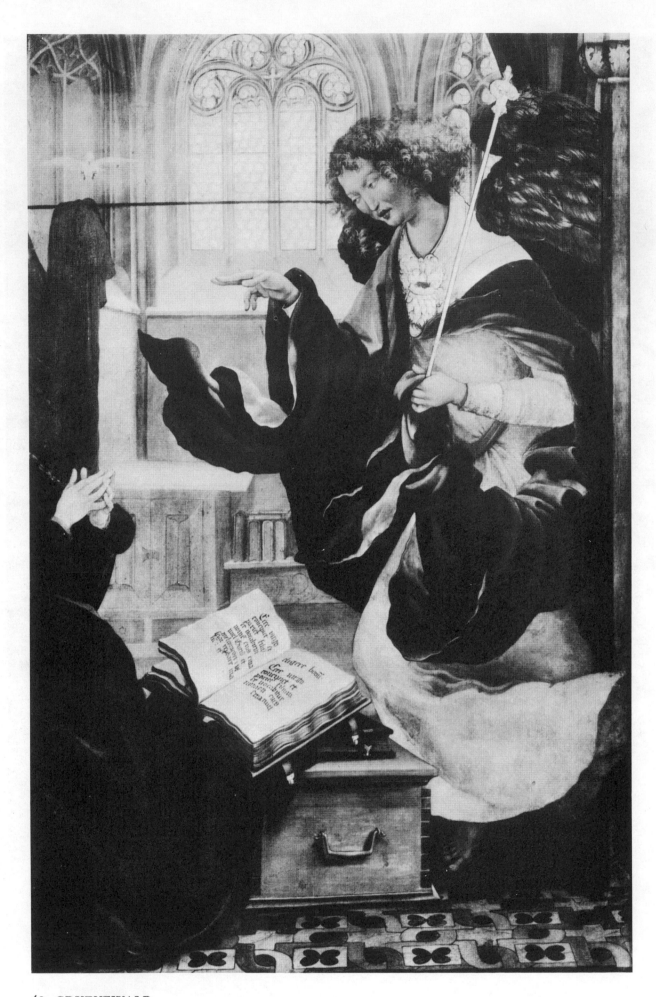

42 GRUENEWALD
 The Angel (Detail from "The Annunciation" on
 the Isenheim Altarpiece)
 Colmar, Museum Unterlinden

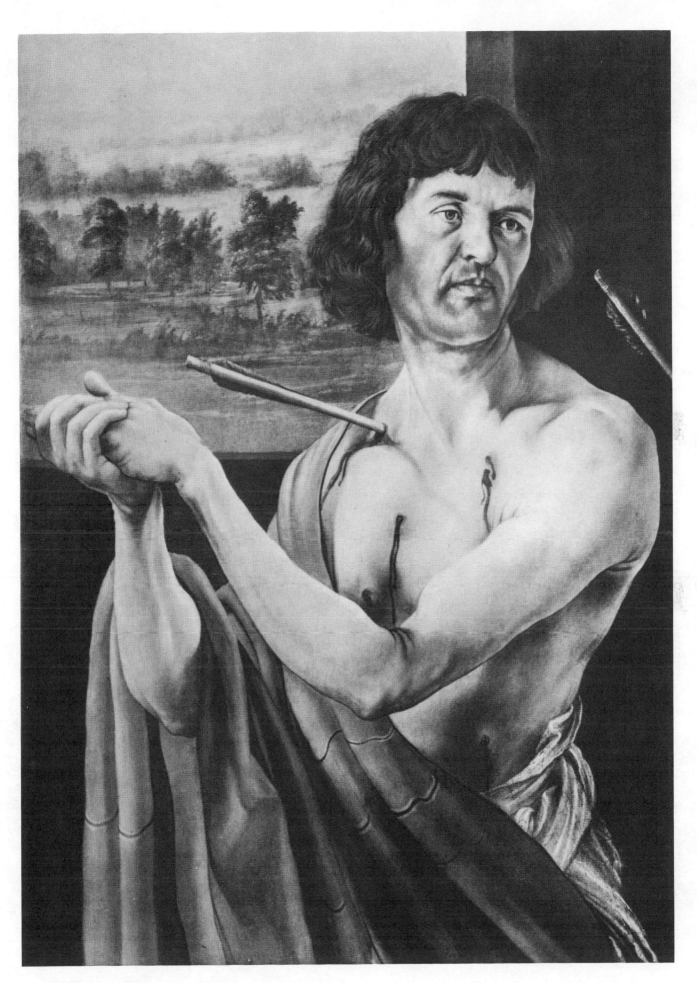

43 GRUENEWALD

St. Sebastian (Detail from the Isenheim Altarpiece)
Colmar, Museum Unterlinden

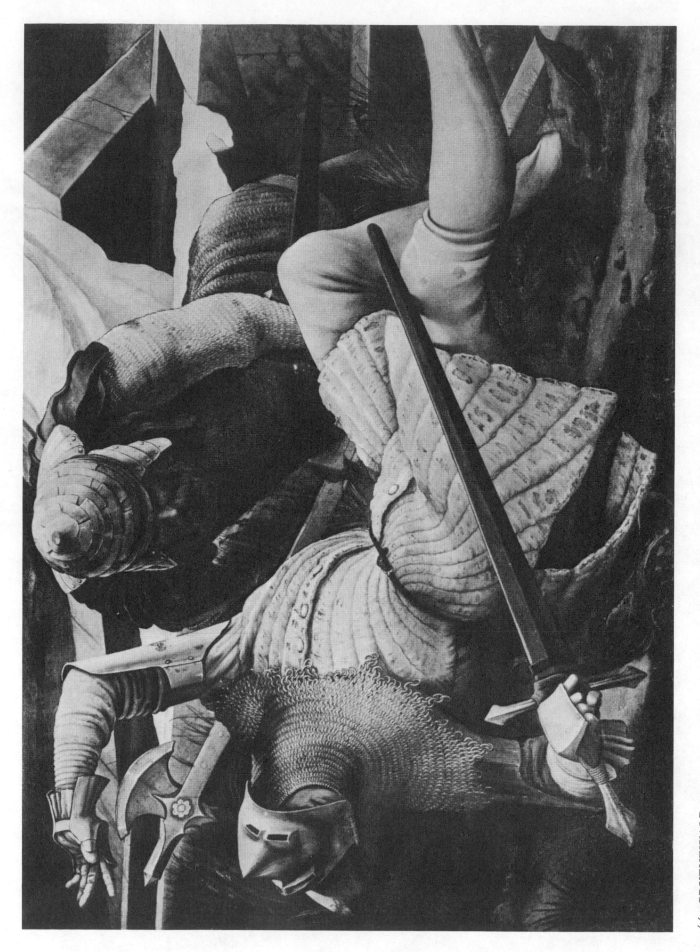

44 GRUENEWALD

The Soldiers (Detail from "The Ascension" on
the Isenheim Altarpiece)
Colmar, Museum Unterlinden

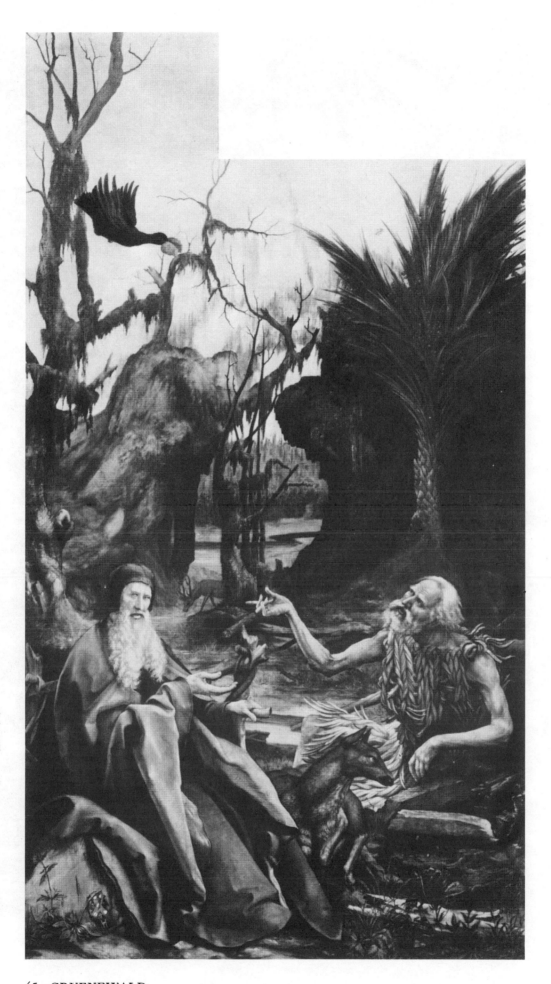

45 **GRUENEWALD**

St. Anthony and St. Paul the Hermit (Detail from
the Isenheim Altarpiece)
Colmar, Museum Unterlinden

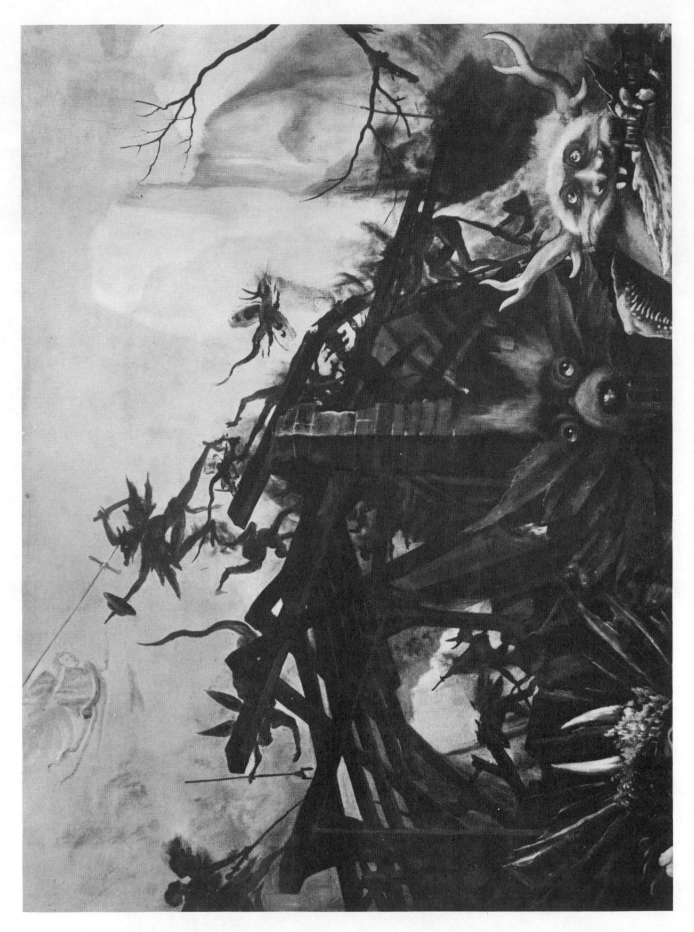

46 GRUENEWALD

The Temptation of St. Anthony (Detail from the
Isenheim Altarpiece)
Colmar, Museum Unterlinden

47 **GRUENEWALD**

The Lamentation over the Dead Christ (Detail
from the Isenheim Altarpiece)
Colmar, Museum Unterlinden

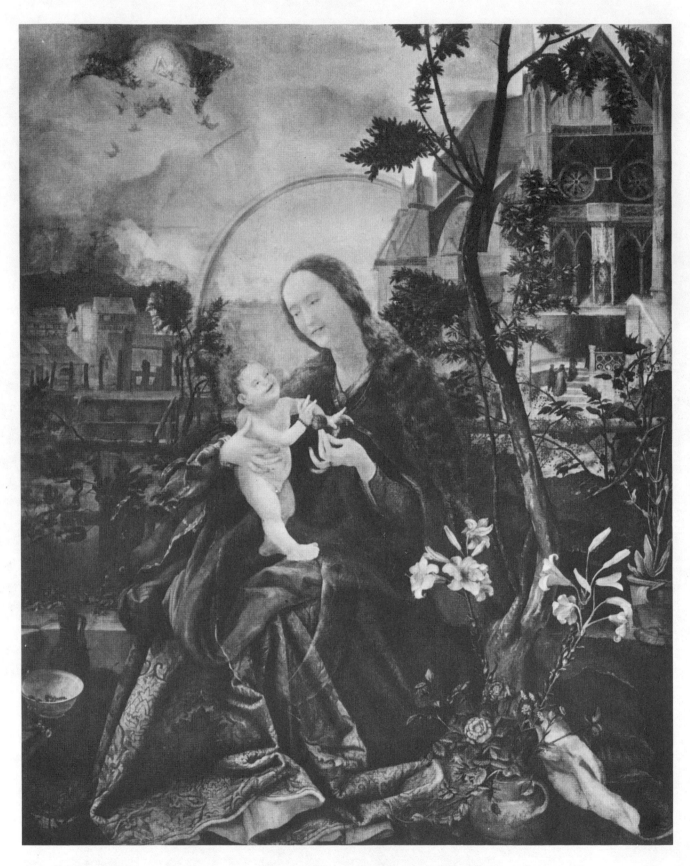

48 GRUENEWALD
Madonna and Child
Stuppach, Pfarrkirche

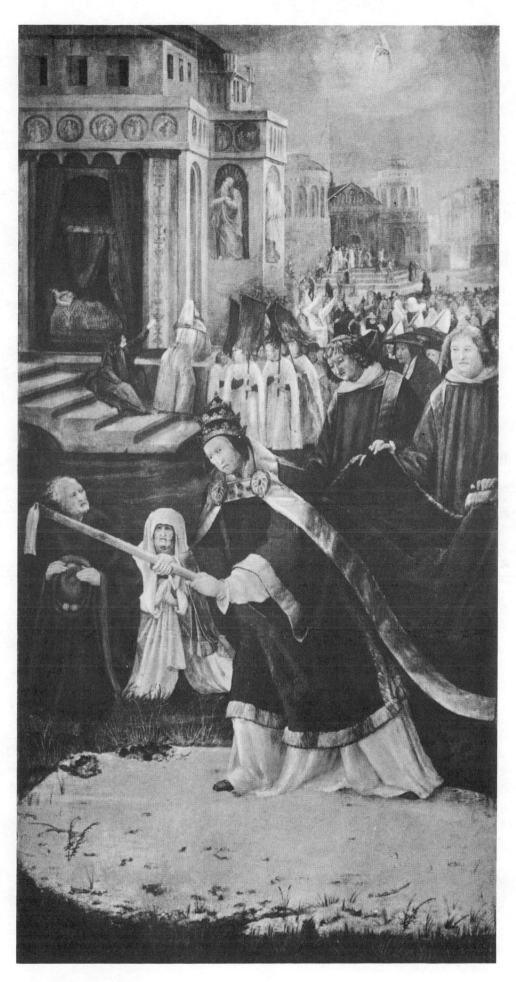

49 **GRUENEWALD**

The Foundation of Sta. Maria Maggiore
Freiburg, Staedtische Kunstsammlungen

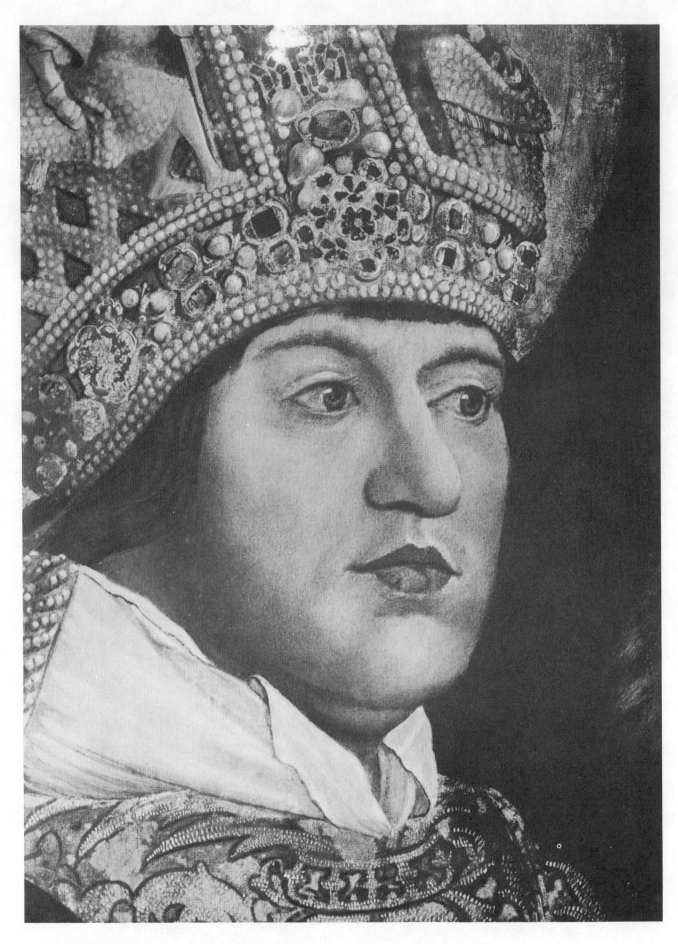

50 GRUENEWALD

The Conversion of St. Maurice (Detail)
Munich, Aeltere Pinakothek

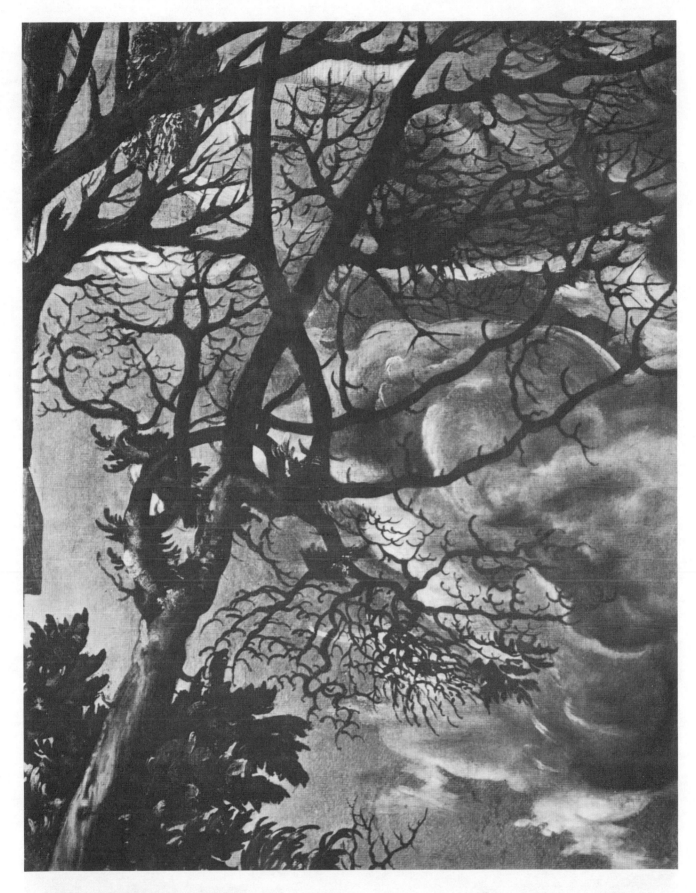

51 **LUCAS CRANACH THE ELDER**

The Crucifixion (Detail)
Munich, Aeltere Pinakothek

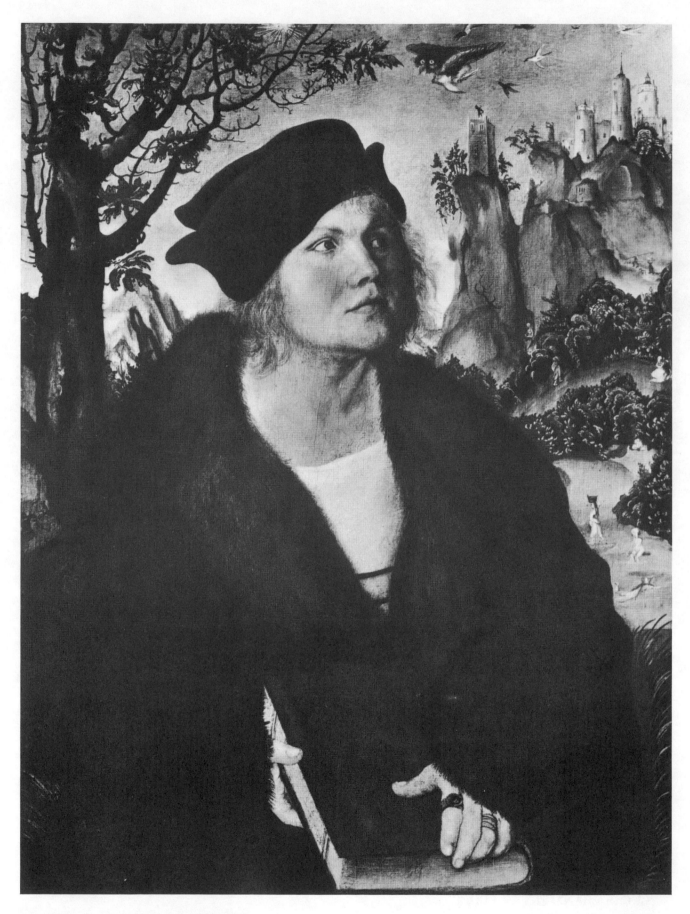

52 LUCAS CRANACH THE ELDER
Portrait of Dr. Johannes Cuspinian
Winterthur, Coll. Oskar Reinhart

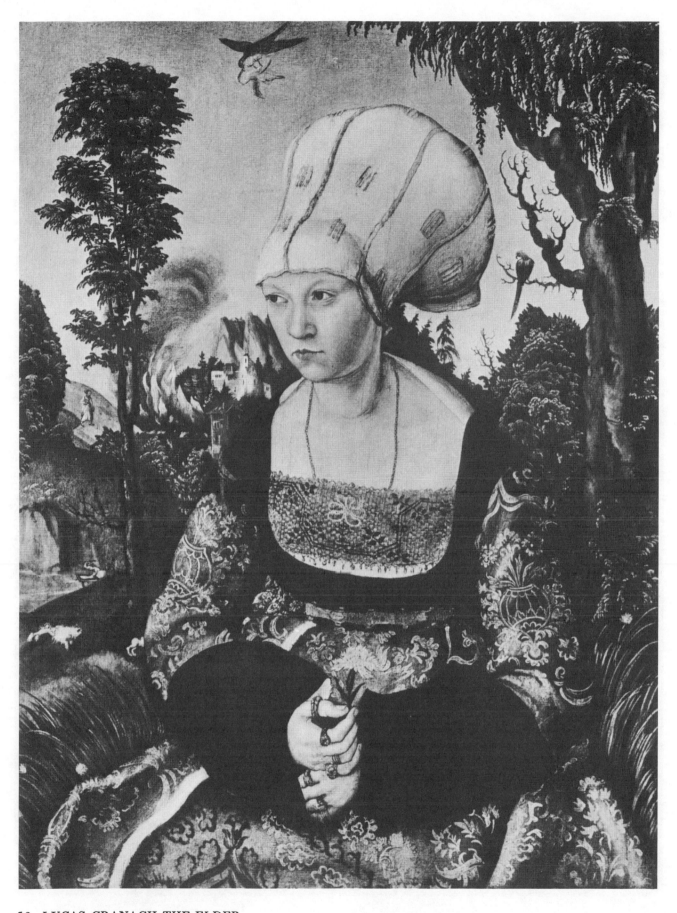

53 **LUCAS CRANACH THE ELDER**

Portrait of Anna Cuspinian
Winterthur, Coll. Oskar Reinhart

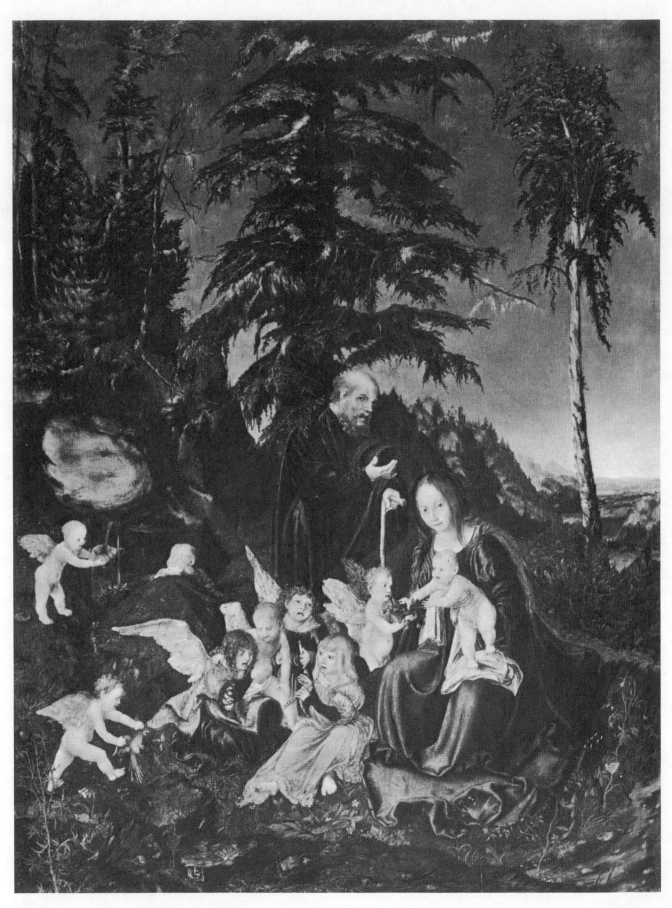

54 LUCAS CRANACH THE ELDER

The Flight into Egypt
Berlin, Deutsches Museum

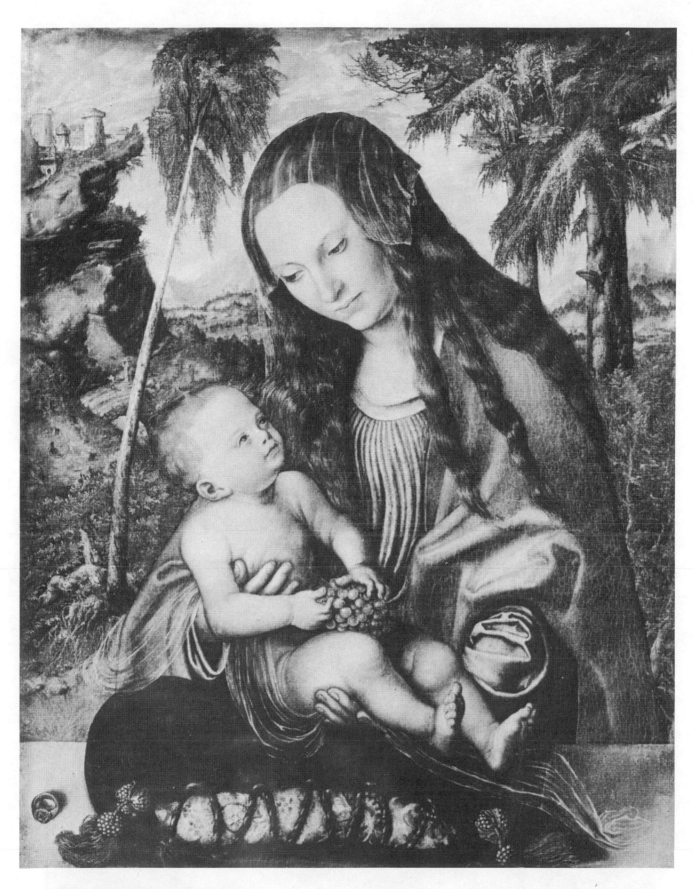

55 **LUCAS CRANACH THE ELDER**
The Madonna and Child under the fir trees
Breslau, Cathedral

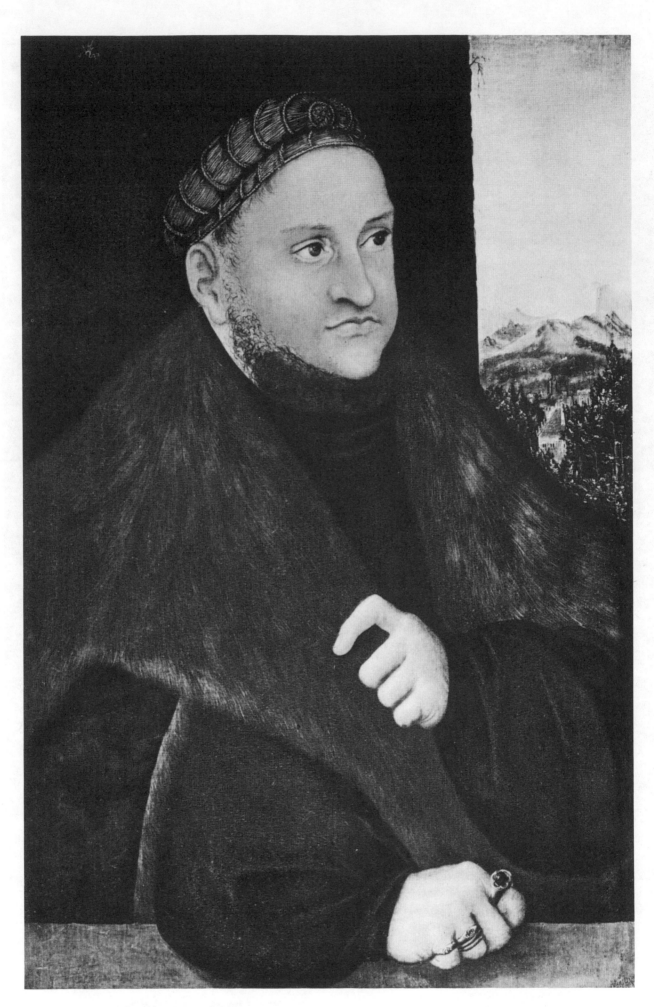

56 LUCAS CRANACH THE ELDER
Portrait of the Elector Frederick the Wise
Berlin, Galerie Haberstock

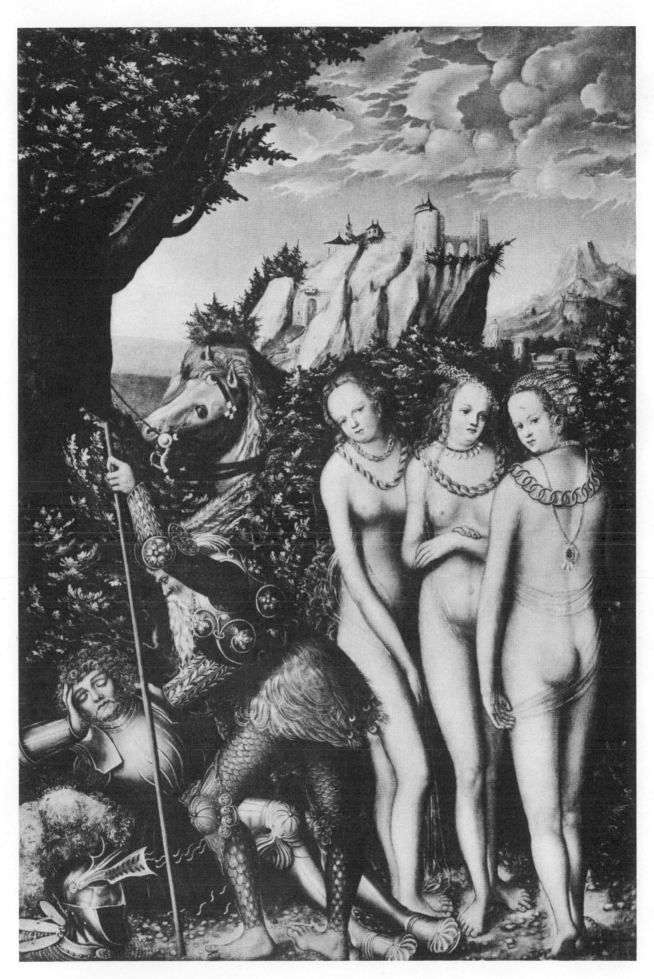

57 LUCAS CRANACH THE ELDER

The Judgment of Paris
Formerly Burg Flechtingen, Coll. Baron v. Schenk

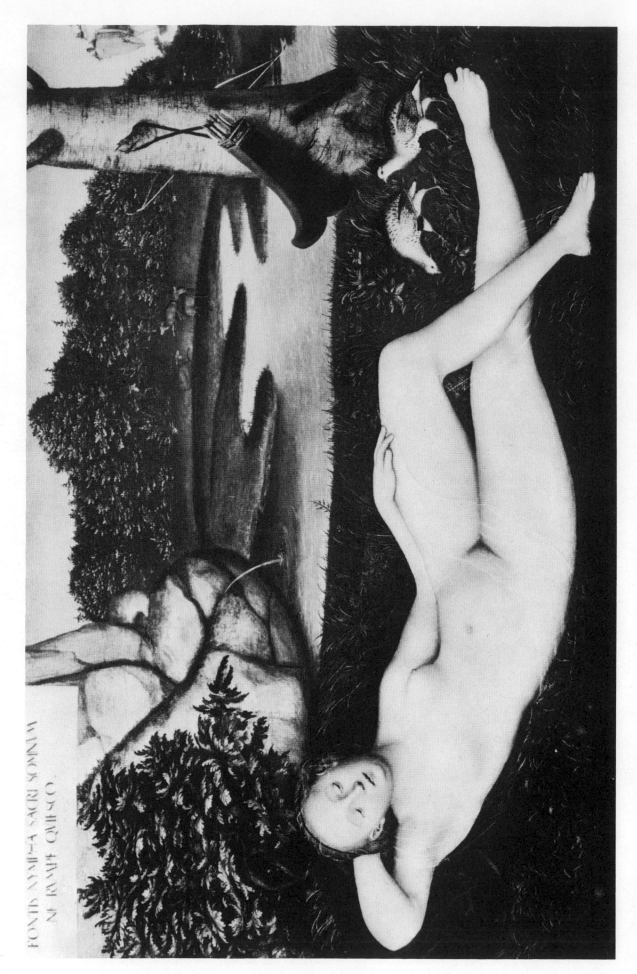

58 LUCAS CRANACH THE ELDER

Nymph resting beside a spring
Lugano, Coll. Baron Thyssen-Bornemisza

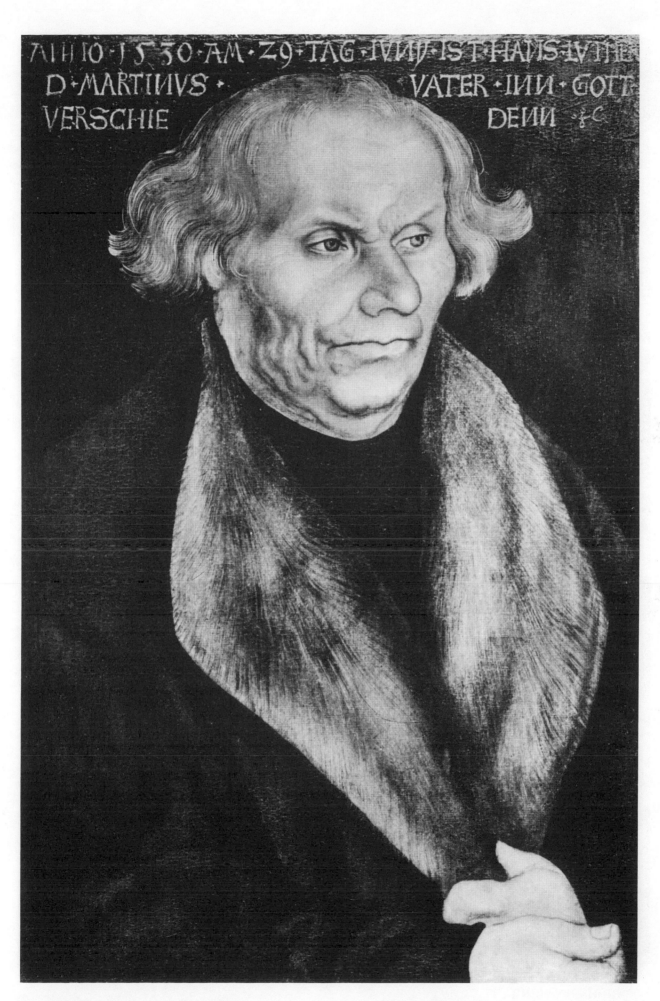

59 LUCAS CRANACH THE ELDER

Portrait of Hans Luther

Wartburg

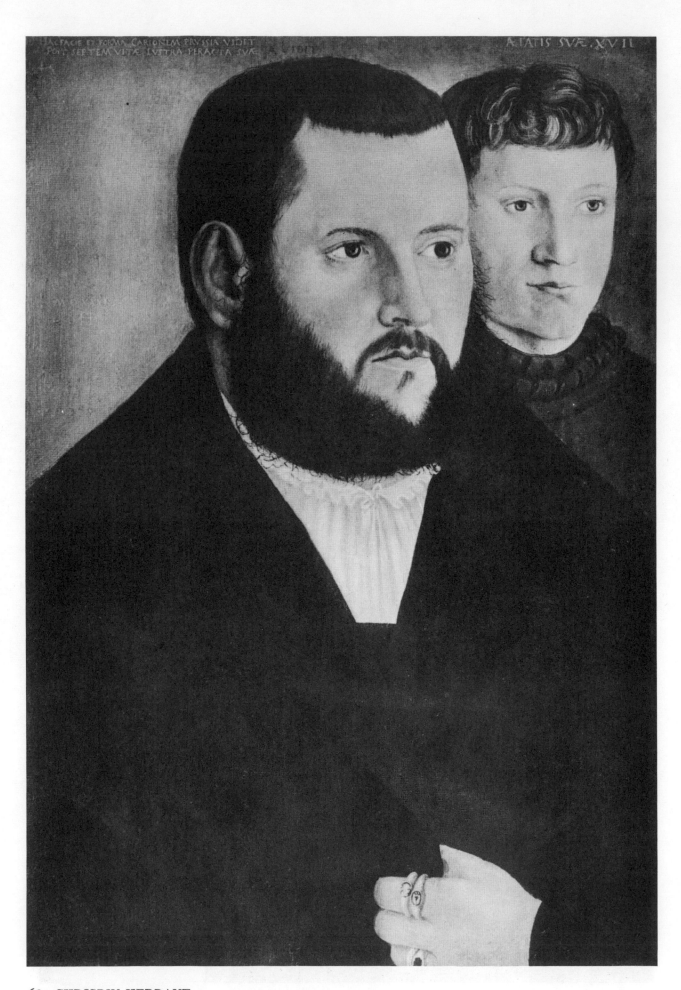

IN FACIE ET FORMA CARIONEM PRVSSIA VIDET
POTQ SERTEM VITÆ LVTTRA PERACTA SVÆ A DIEI
AETATIS SVÆ XVII

60 CHRISPIN HERRANT
Portrait of Johann Carion
Koenigsberg, Kunstsammlungen der Stadt

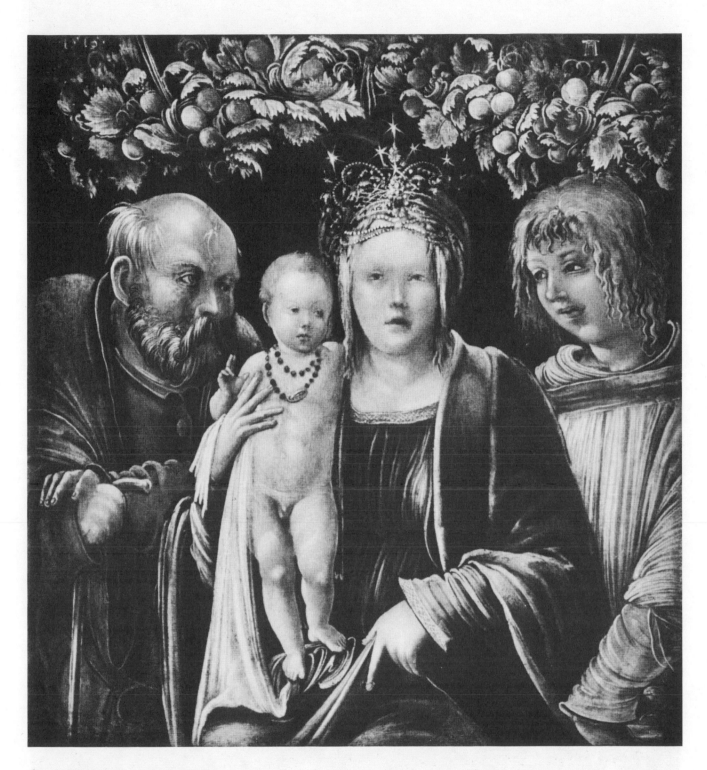

61 **ALBRECHT ALTDORFER**

The Virgin and Child with S.S. Joseph and John
 the Evangelist
Vienna, Kunsthistorisches Museum

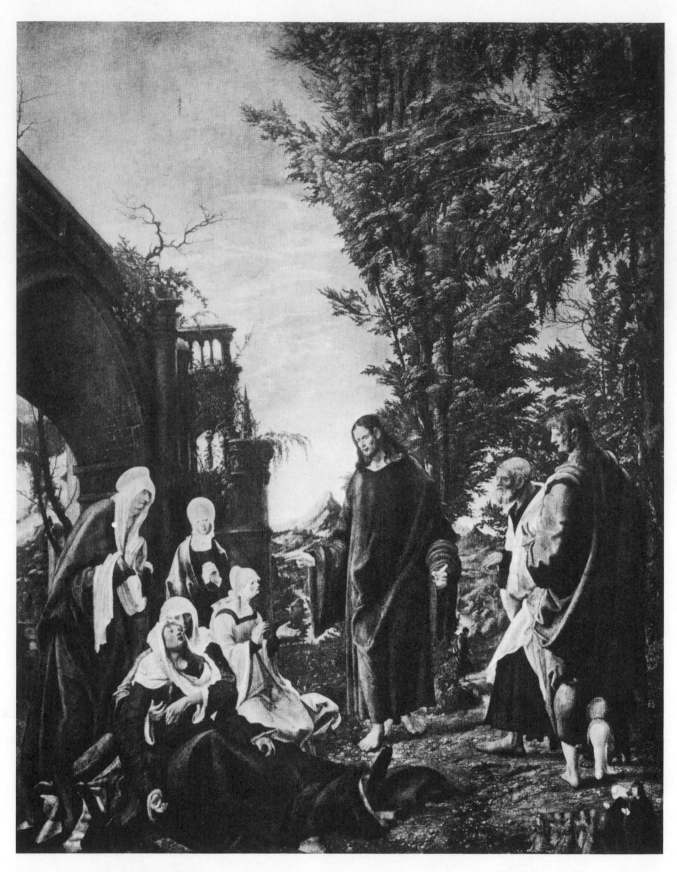

62 **ALBRECHT ALTDORFER**
Christ taking leave of His Mother
London, Coll. Wernher

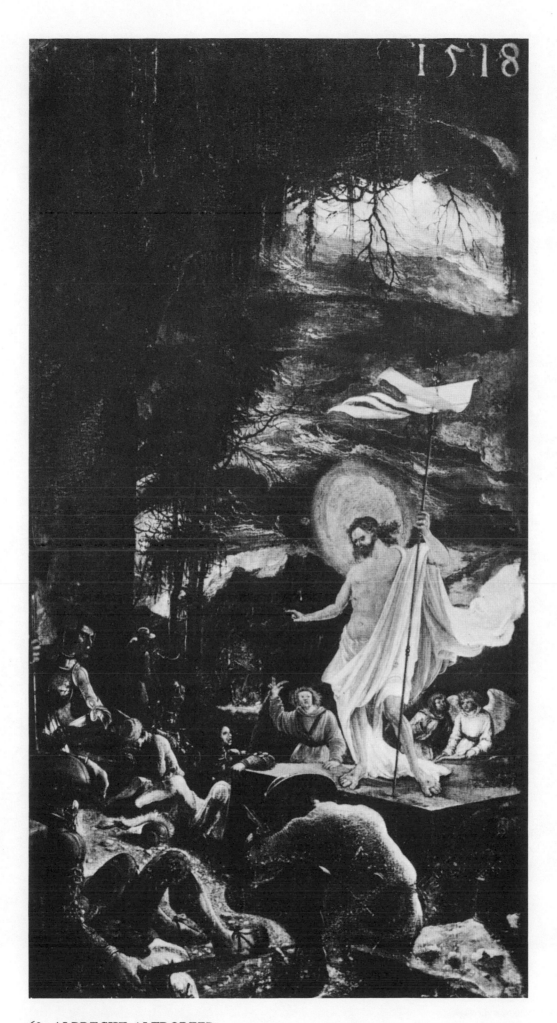

63 **ALBRECHT ALTDORFER**
The Resurrection
Vienna, Kunsthistorisches Museum

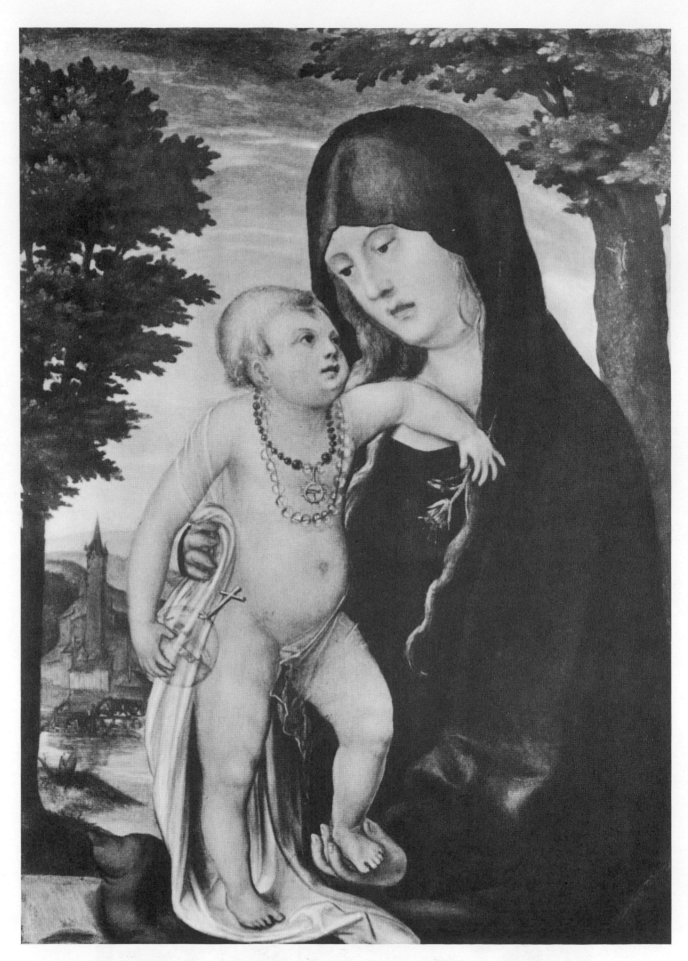

64 **ALBRECHT ALTDORFER**
The Madonna and Child
Berlin, Private collection

65 ALBRECHT ALTDORFER

The Battle of Arbela (Detail)
Munich, Aeltere Pinakothek

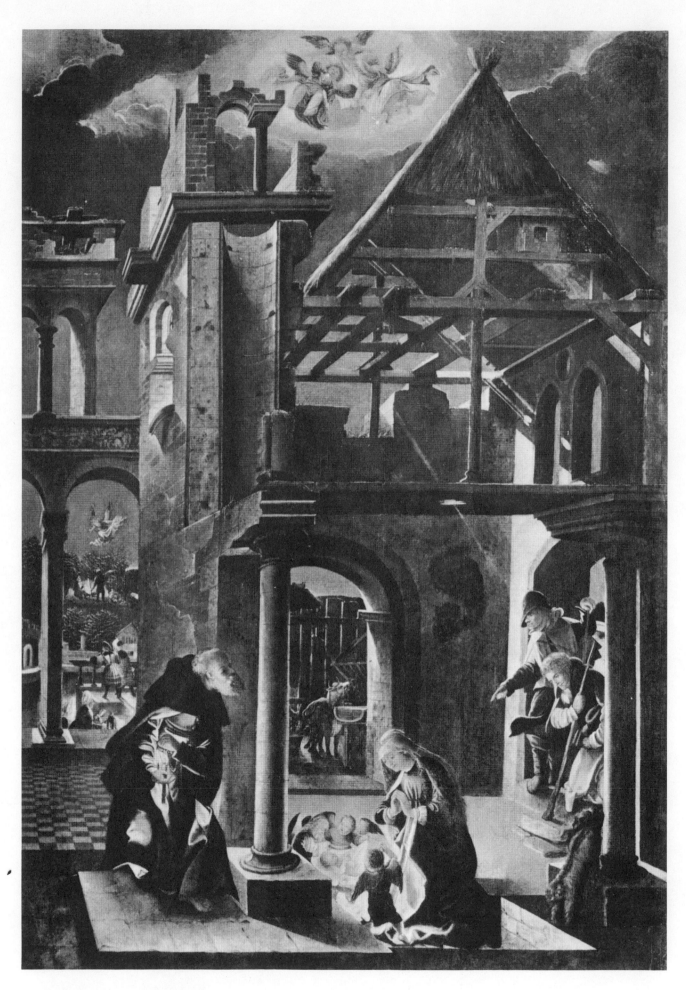

66 **ALBRECHT ALTDORFER**
The Nativity
Berlin, Deutsches Museum

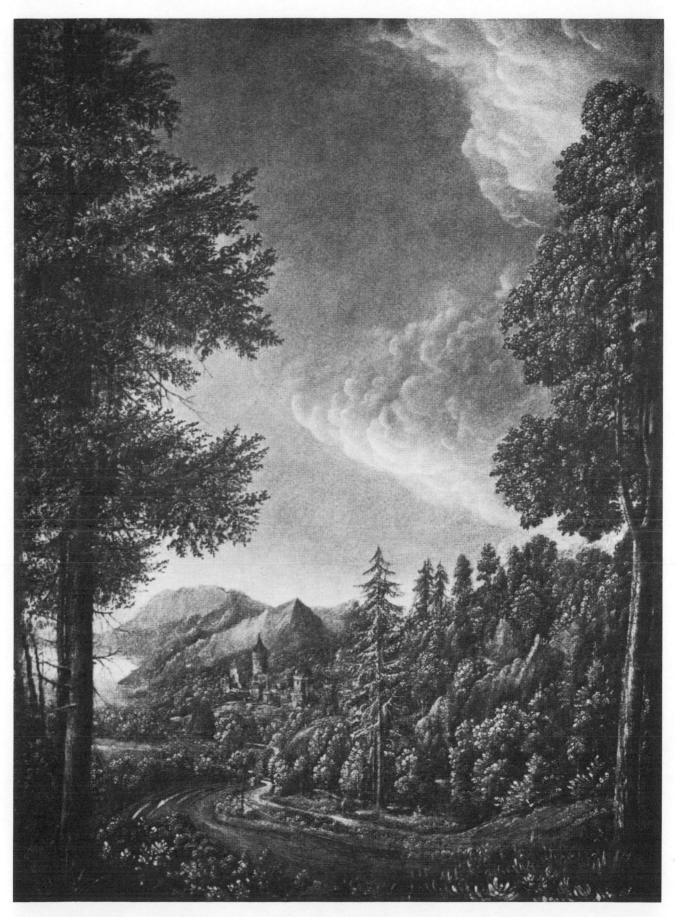

67 **ALBRECHT ALTDORFER**
Landscape
Munich, Aeltere Pinakothek

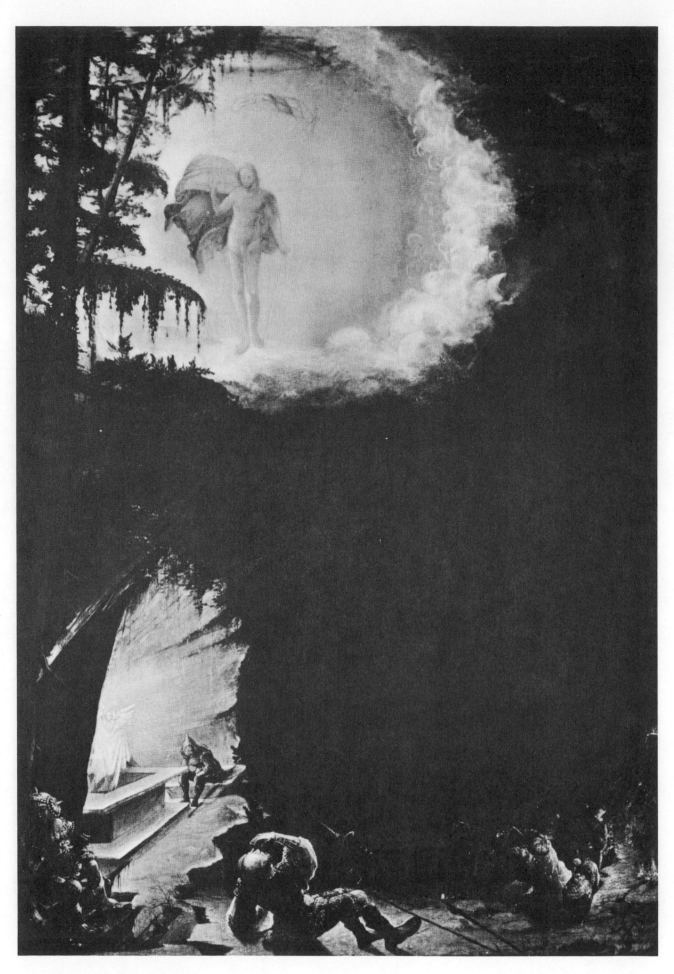

68 **ABRAHAM SCHÖPFER** (?)

The Resurrection
Basle, Oeffentliche Kunstsammlung

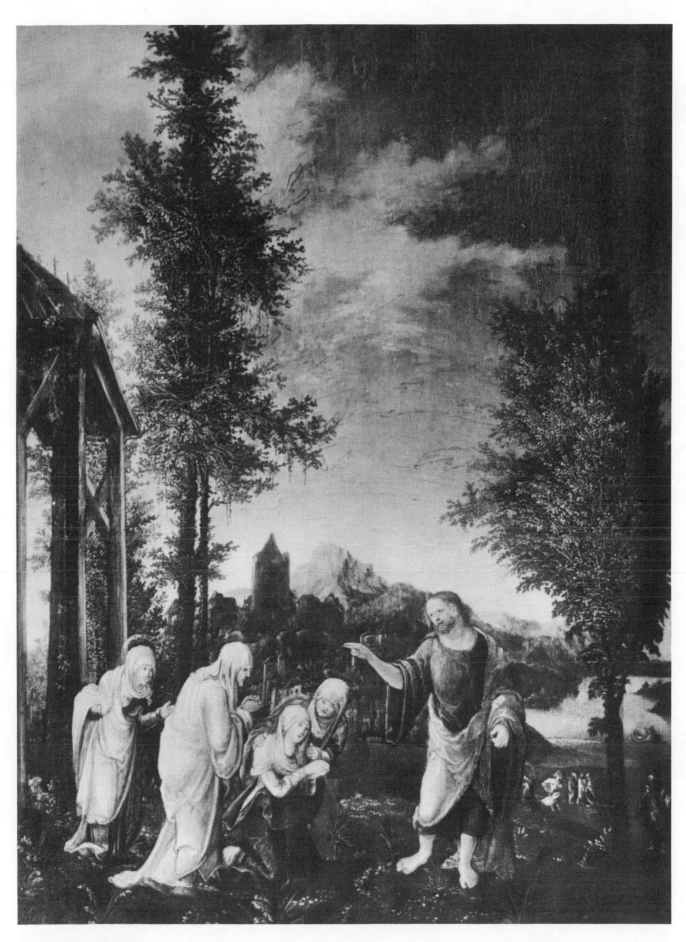

69 **WOLF HUBER**
Christ taking leave of His Mother
Vienna, Kunsthistorisches Museum

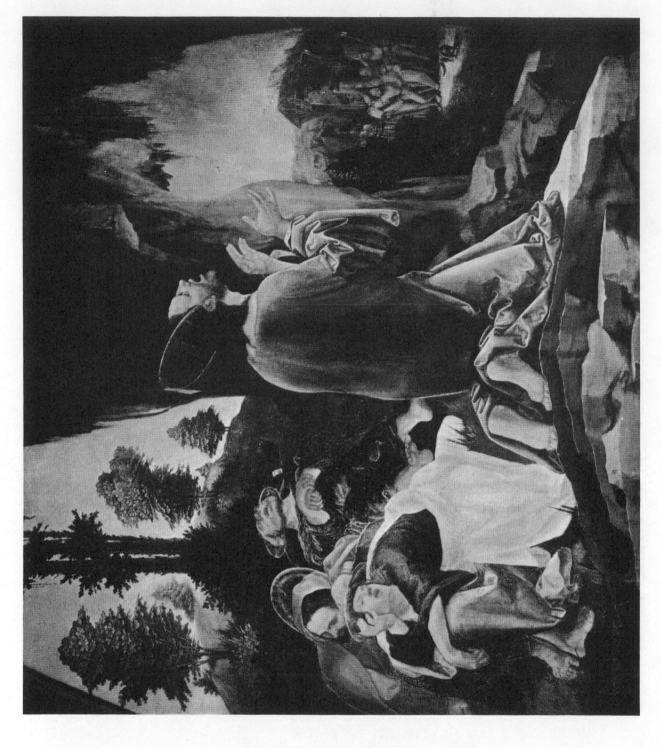

70 WOLF HUBER
Christ on The Mount of Olives
Munich, Aeltere Pinakothek

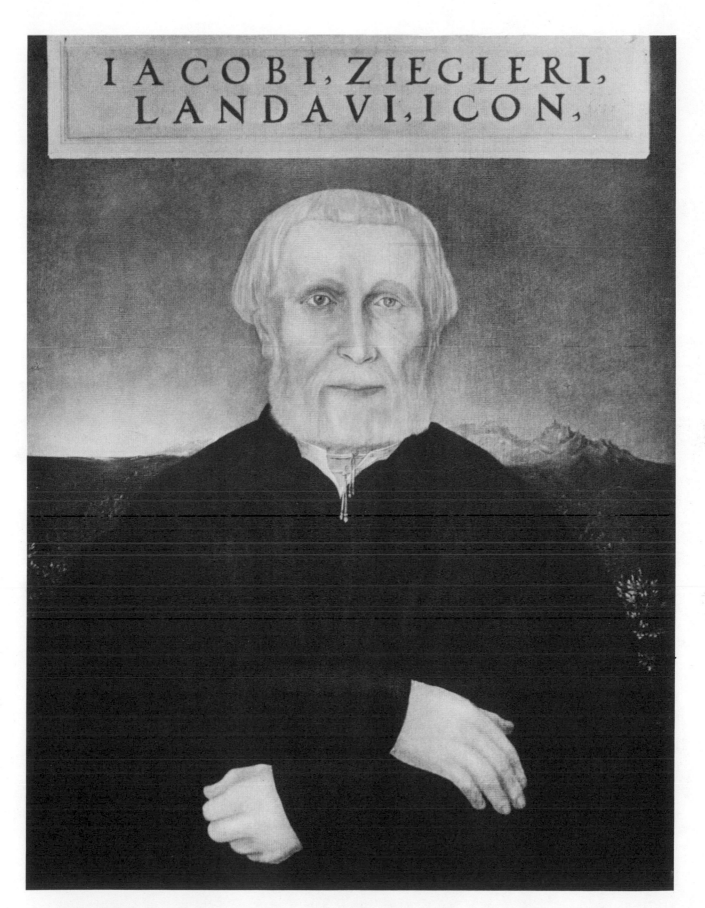

71 WOLF HUBER
Portrait of Jakob Ziegler
Vienna, Kunsthistorisches Museum

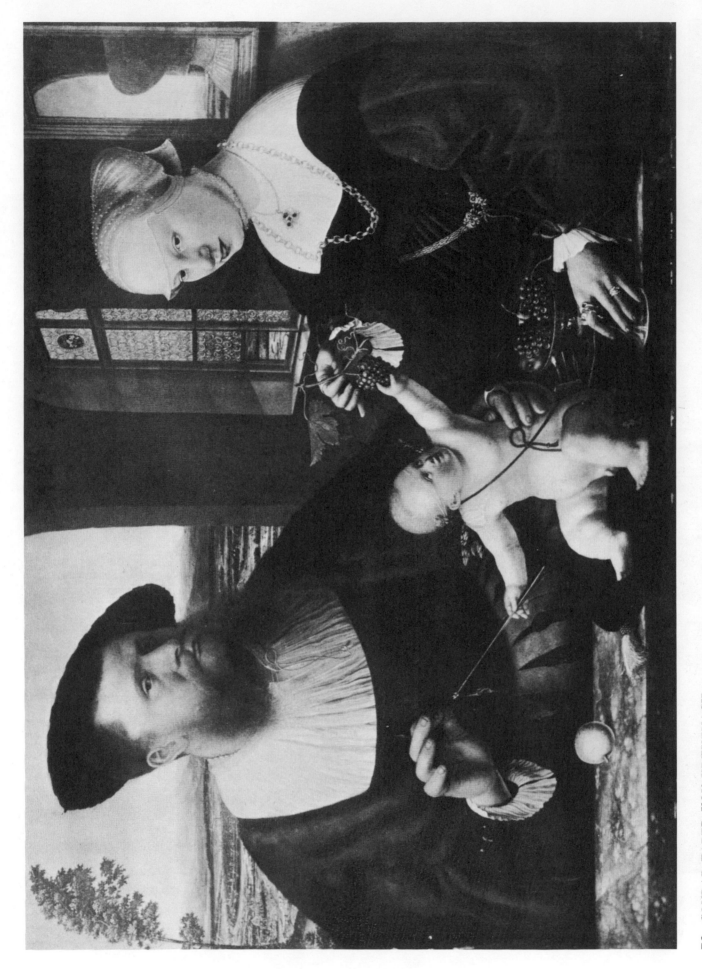

72 CONRAD FABER VON KREUZNACH

Portrait of Justinian and Anna von Holzhausen
Frankfort on Main, Staedel Institute

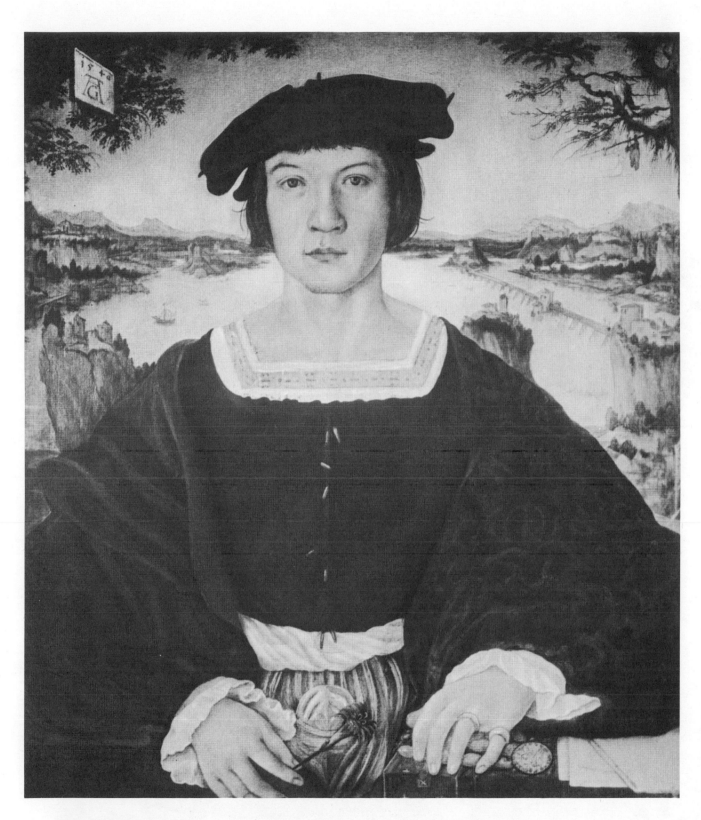

73 THE MASTER A. G. OF 1540

Portrait of a young man
Vienna, Liechtenstein Gallery

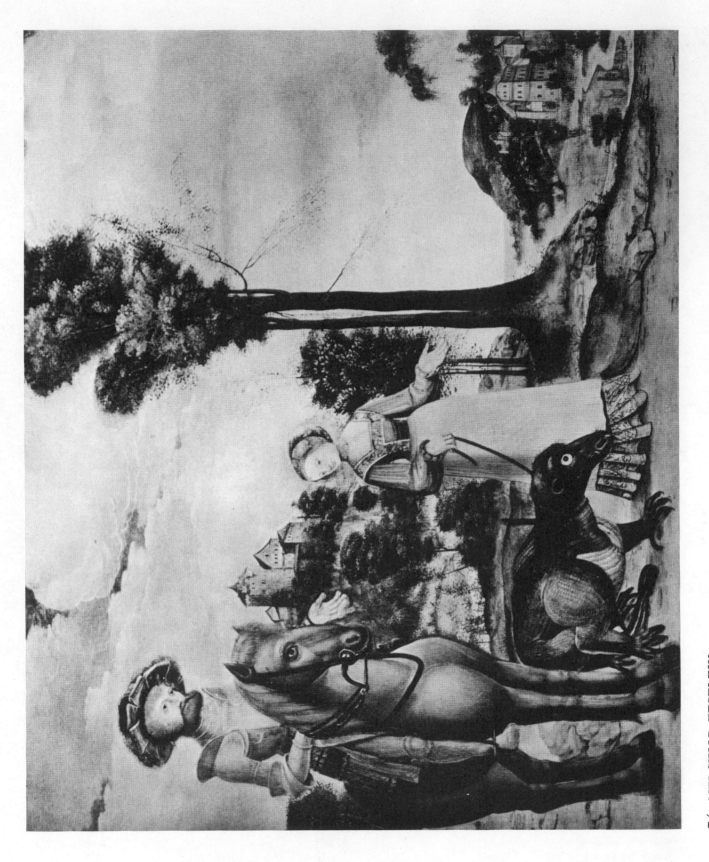

74 **MELCHIOR FESELEIN**

St. George
Leipzig, Museum der bildenden Kuenste

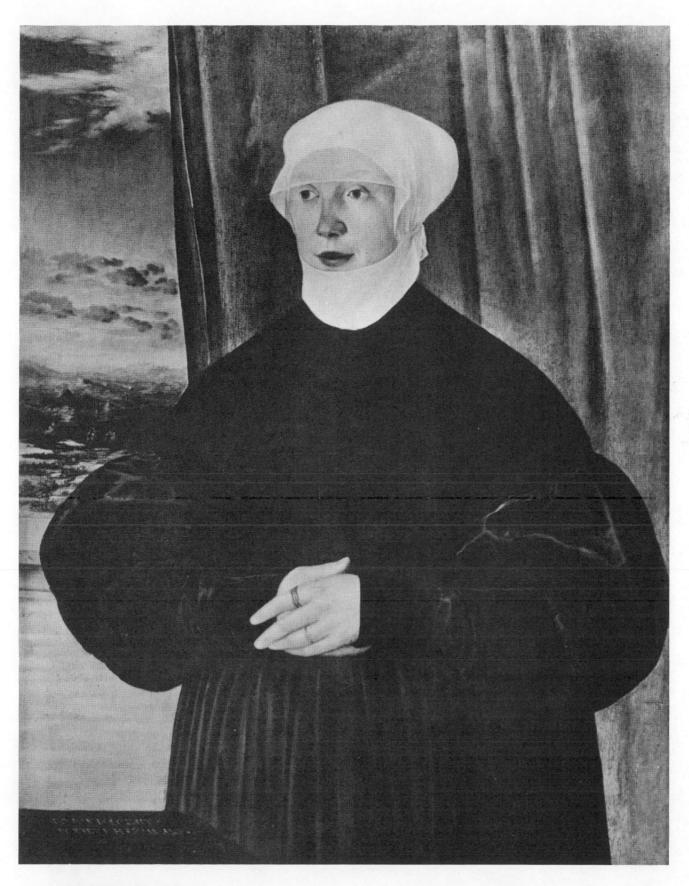

HANS MIELICH
Portrait of the Wife of Andreas Liegsalz
Munich, Aeltere Pinakothek

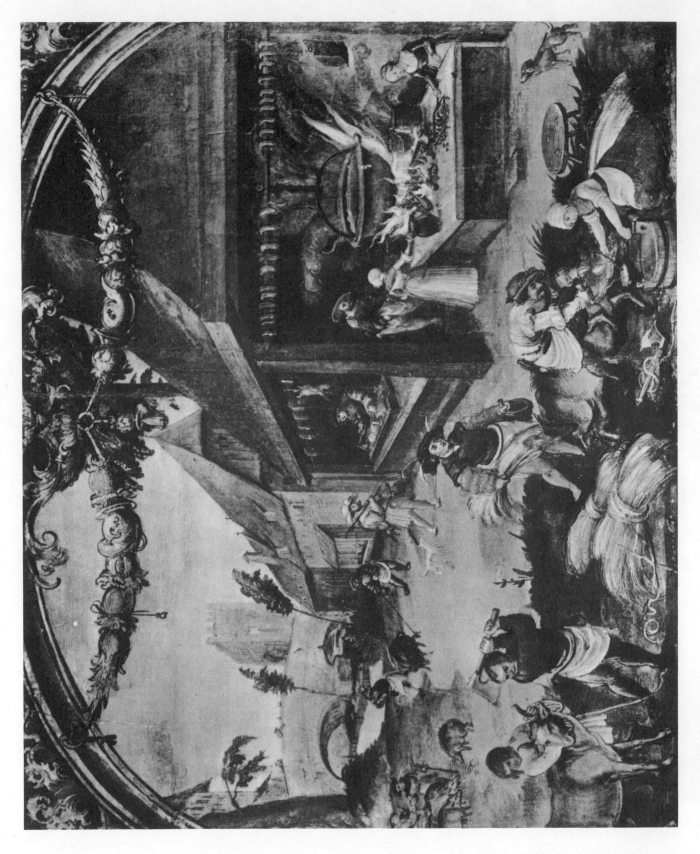

76 HANS WERTINGER

December
Nuremberg, Germanisches Nationalmuseum

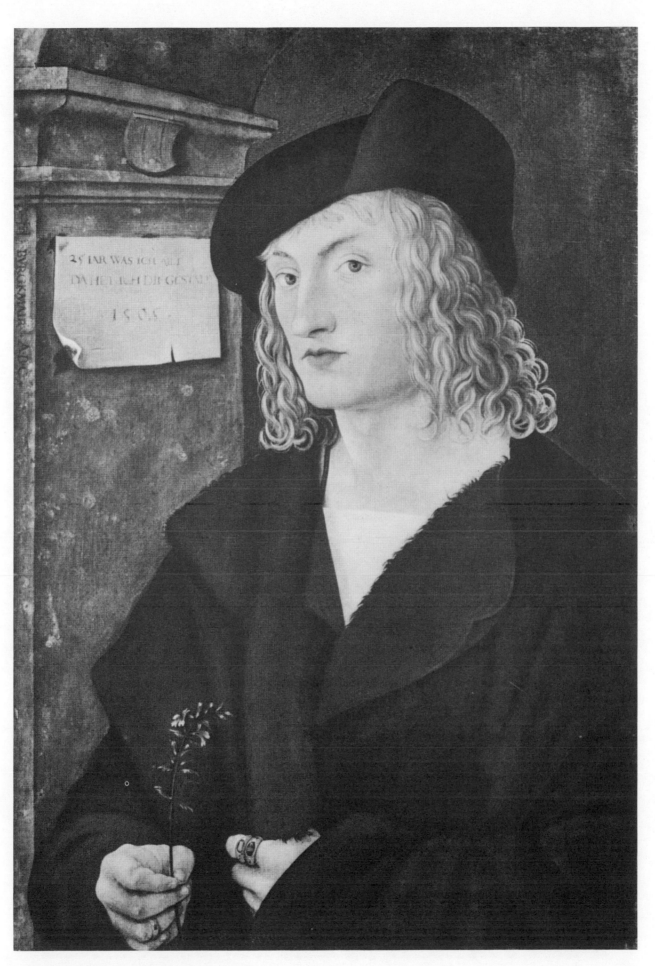

77 HANS BURGKMAIR THE ELDER

Portrait of Hans Schellenberger
Cologne, Wallraf-Richartz Museum

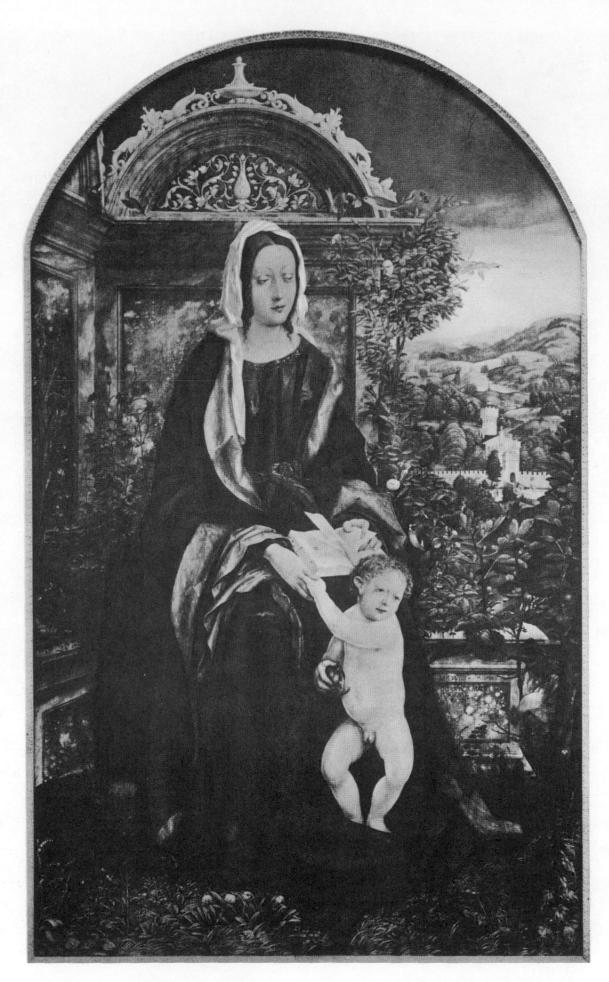

78 HANS BURGKMAIR THE ELDER

The Madonna and Child
Nuremberg, Germanisches Nationalmuseum

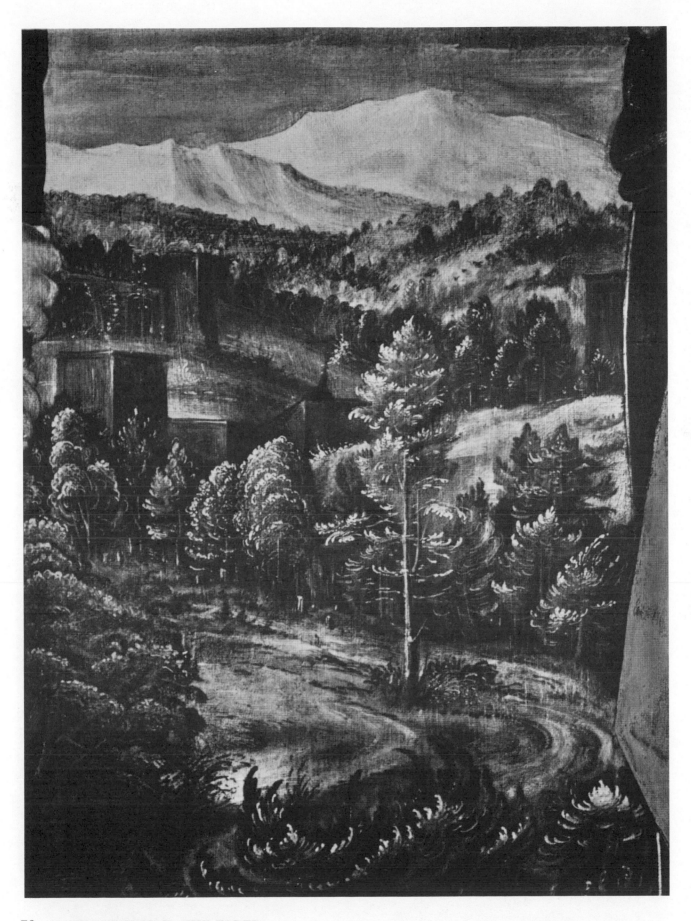

79 HANS BURGKMAIR THE ELDER
Landscape (Detail from the centre panel of the
Crucifixion Altarpiece)
Munich, Aeltere Pinakothek

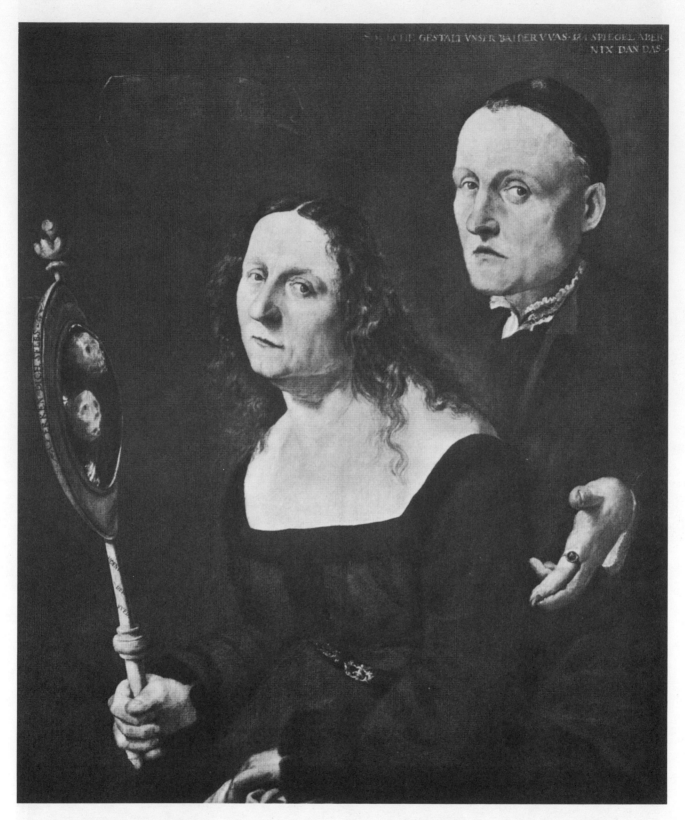

80 LUCAS FURTENAGEL
Portrait of Hans Burgkmair with his wife
Vienna, Kunsthistorisches Museum

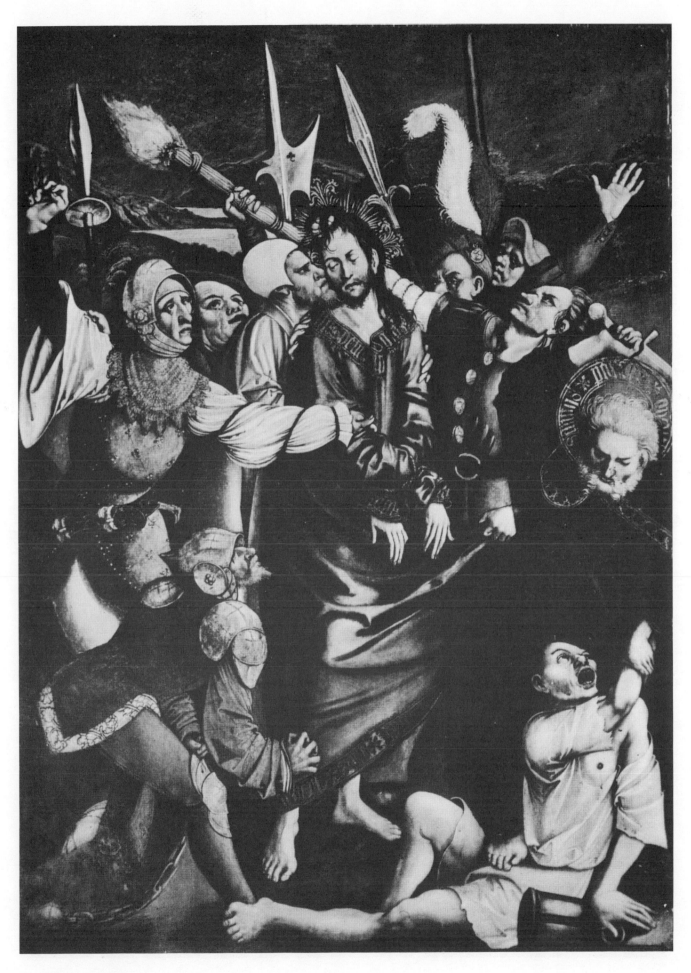

81 JOERG BREU

Christ taken Prisoner
Melk, Stiftsgalerie

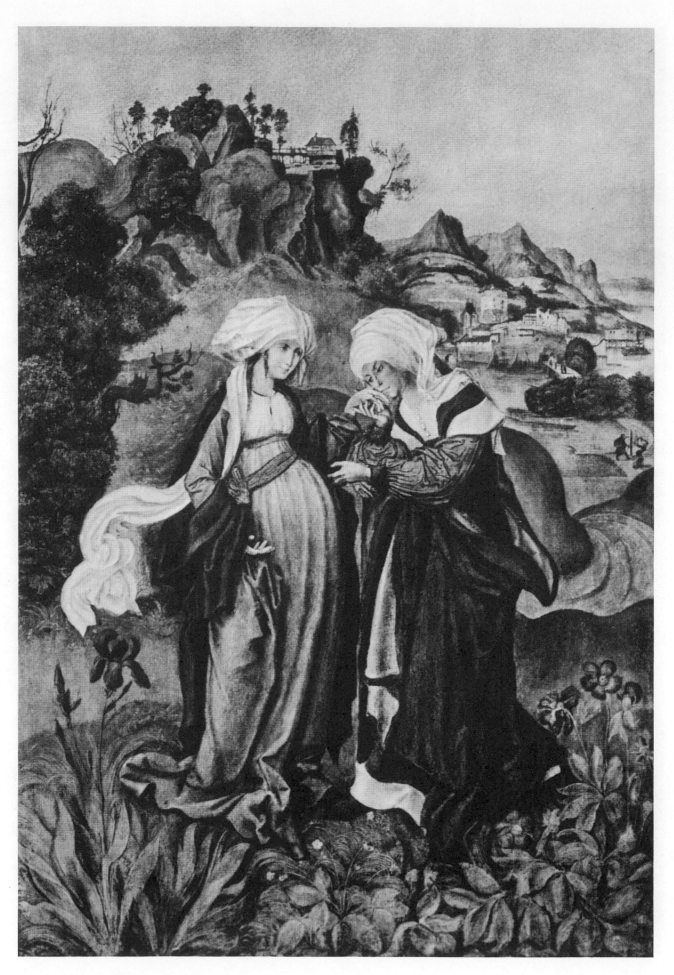

82 JOERG BREU

The Visit of The Virgin to St. Elizabeth
Budapest, Gemaeldegalerie

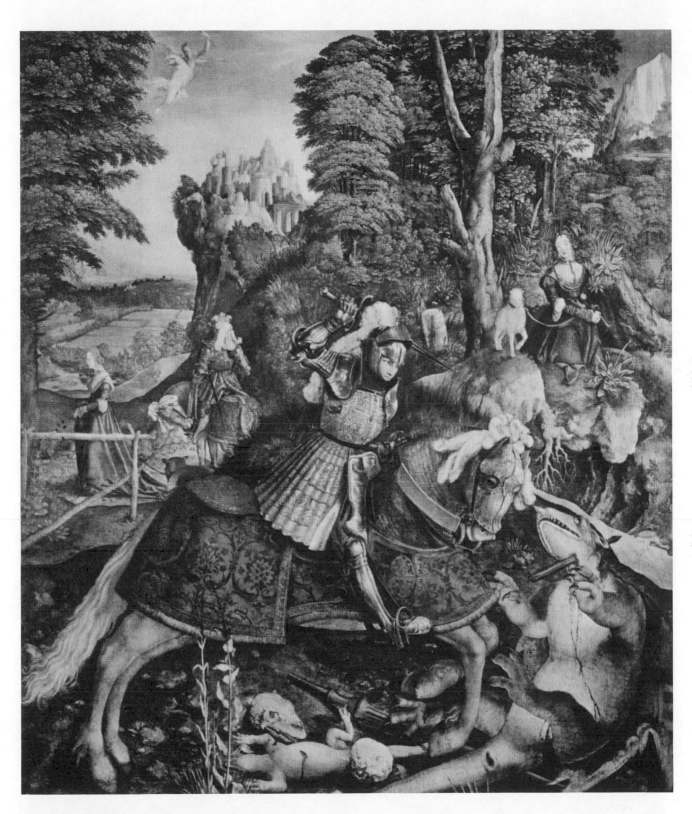

83 LEONHARD BECK

St. George
Vienna, Kunsthistorisches Museum

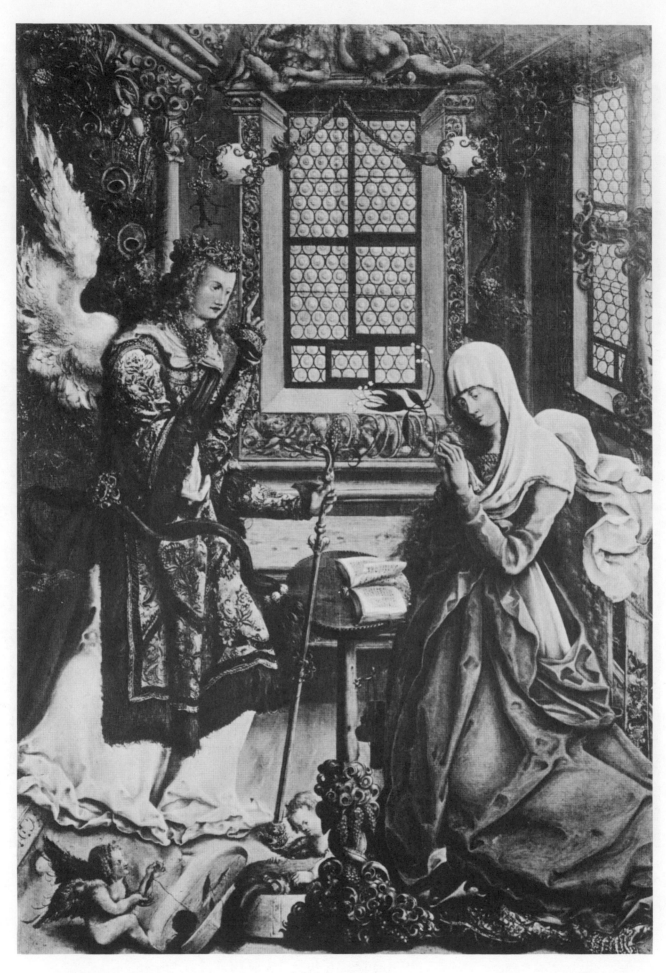

84 DANIEL HOPFER
The Annunciation
Augsburg, St. Jacob

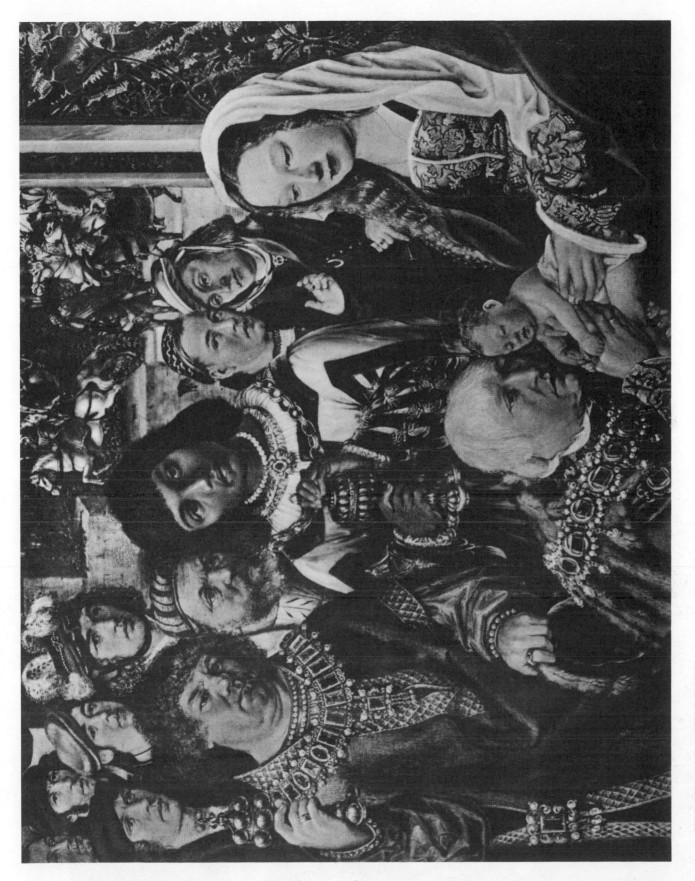

85 ULRICH APT THE ELDER
The Adoration of the Kings (Detail)
Paris, Louvre

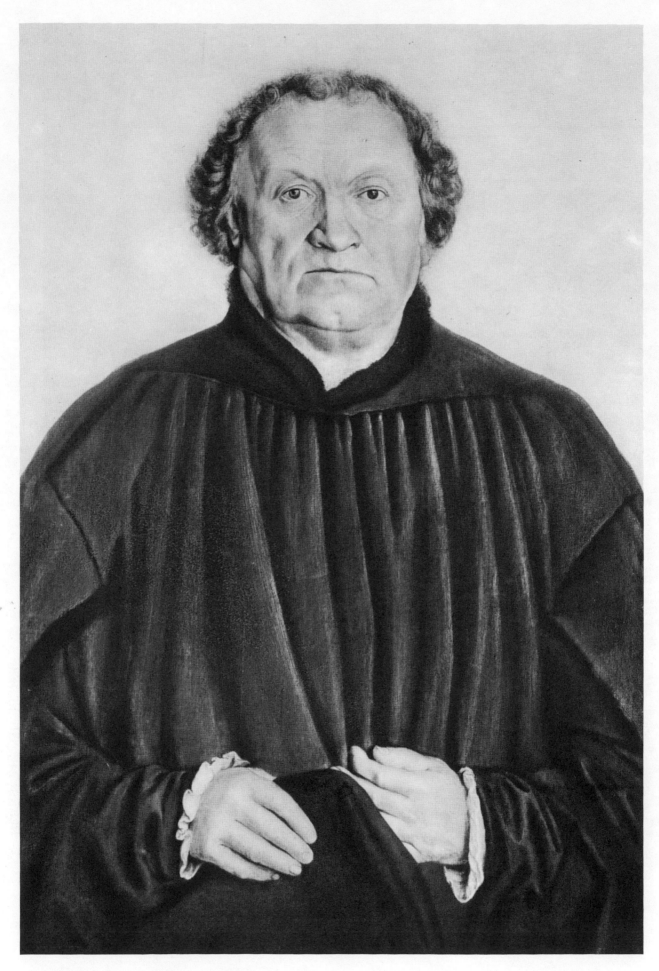

86 THE MASTER OF THE ANGRER PORTRAITS (?)

Portrait of a man
Dresden, Gemaeldegalerie

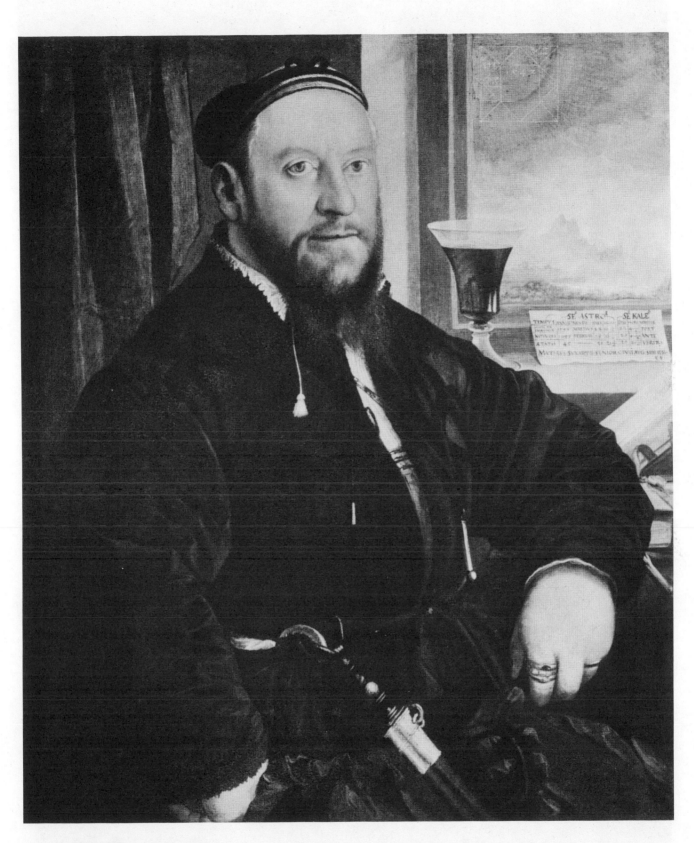

87 CHRISTOPH AMBERGER
Portrait of Matthaeus Schwartz
Berlin, Galerie Haberstock

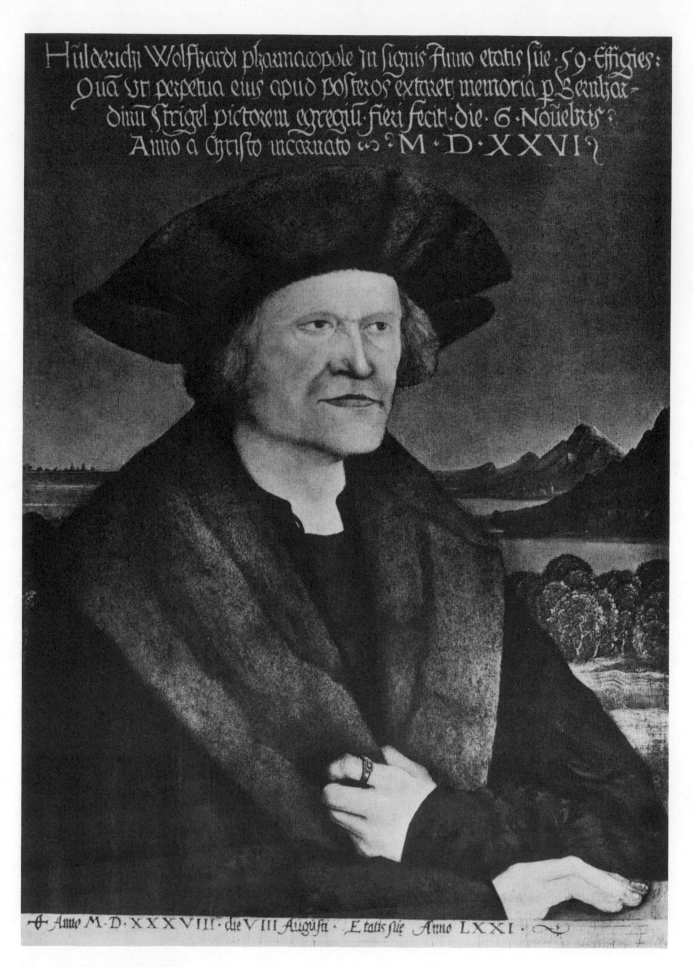

Huldenchi Wolffzardi pharmacopole in signis Anno etatis sue · 59 · Effigies:
Qua vt perpetua eius apud posteros extaret memoria p Bernhar-
dinu Strigel pictorem egregiu fieri fecit · die · 6 · Nouebris ·
Anno a Christo incarnato · M · D · XXVI ·

Anno M · D · XXXVIII · die VIII Augusti · Etatis sue Anno LXXI ·

88 BERNHARD STRIGEL

Portrait of the Apothecary Wolfhardt
German Private Collection

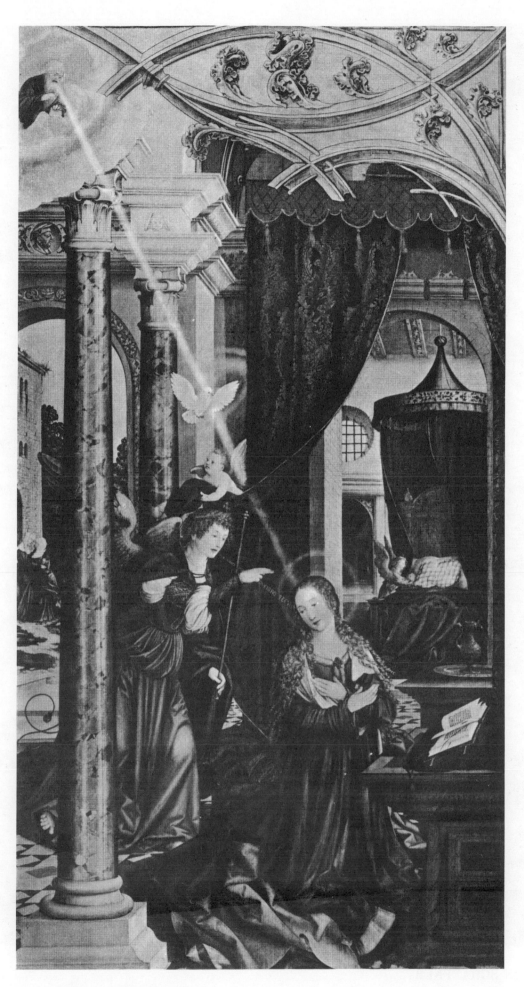

89 **MARTIN SCHAFFNER**
The Annunciation
Munich, Aeltere Pinakothek

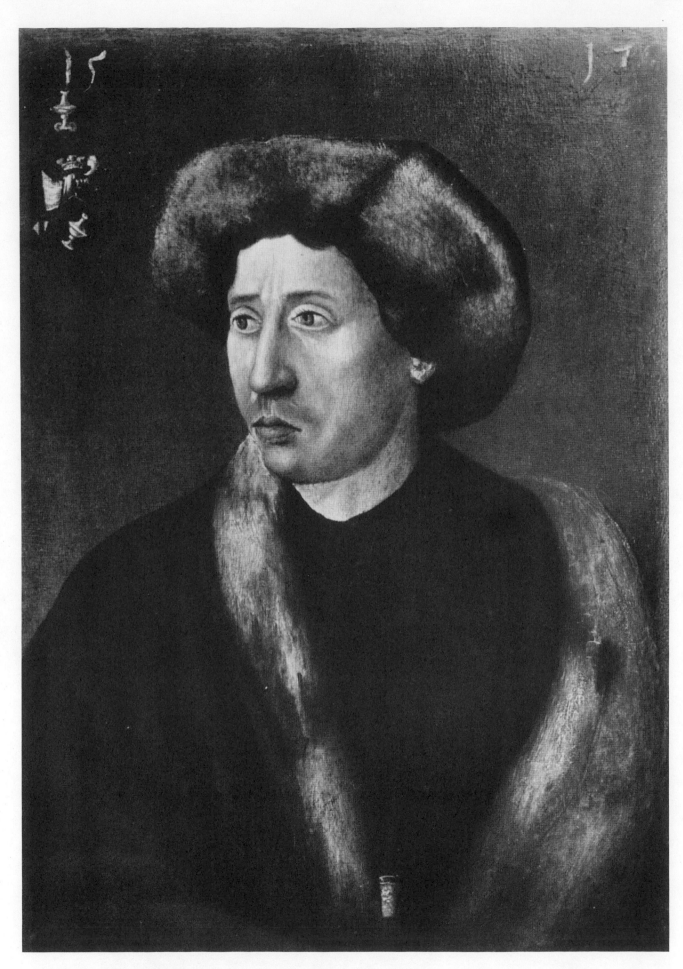

90 **MARTIN SCHAFFNER**
Portrait of Bernhard Besserer
Ulm, Cathedral

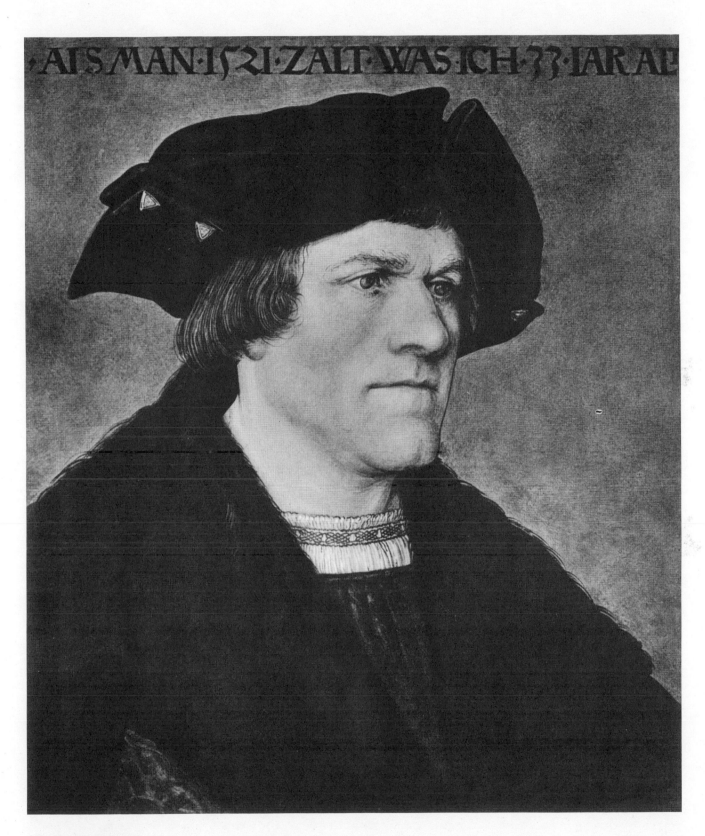

91 HANS MALER

Portrait of a young man
Vienna, Kunsthistorisches Museum

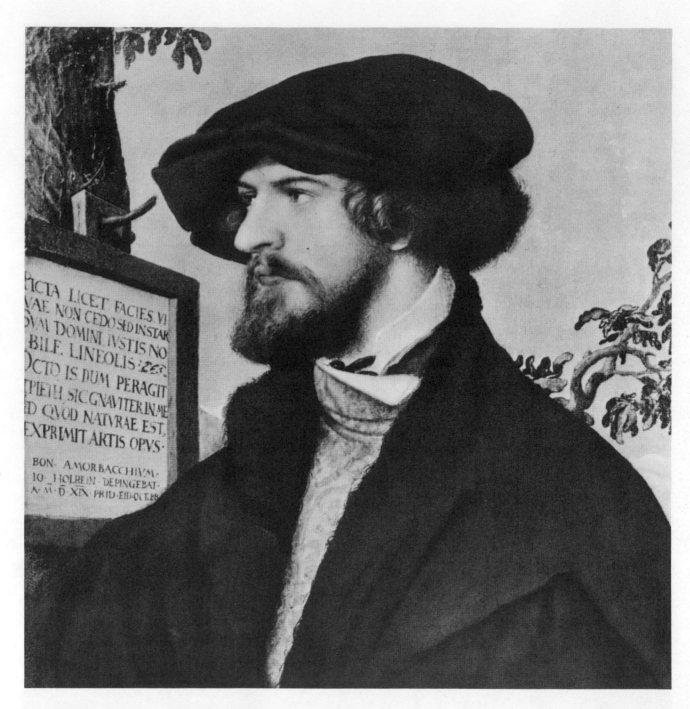

92 HANS HOLBEIN THE YOUNGER
 Portrait of Bonifacius Amerbach
 Basle, Oeffentliche Kunstsammlung

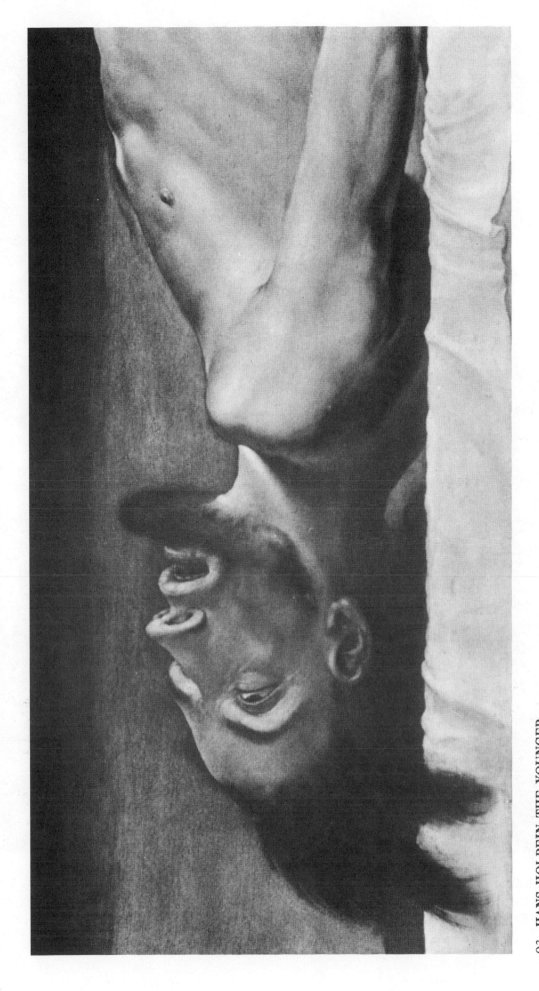

93 HANS HOLBEIN THE YOUNGER
The Dead Christ (Detail)
Basle, Oeffentliche Kunstsammlung

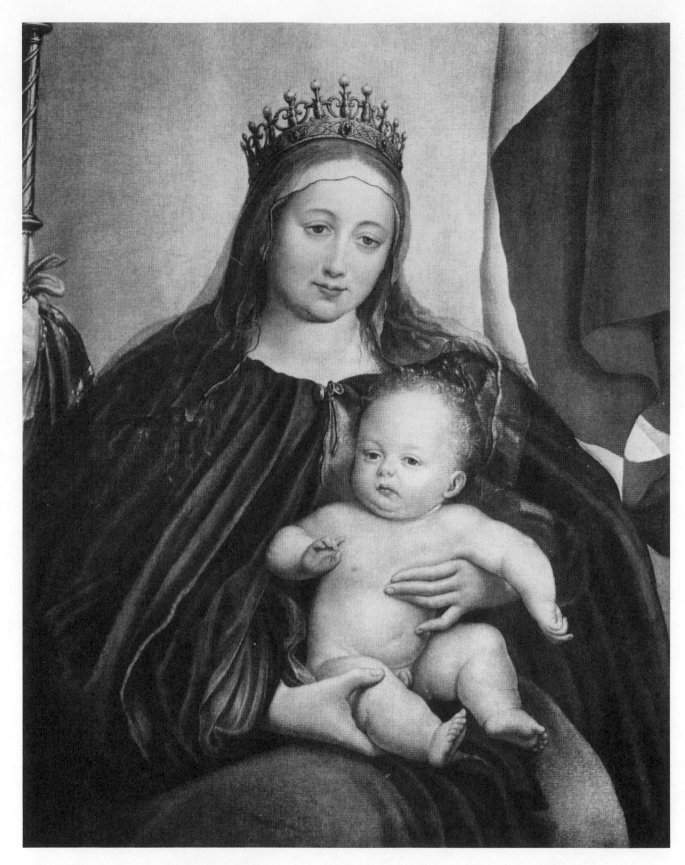

94 **HANS HOLBEIN THE YOUNGER**

The Solothurn Madonna (Detail)
Solothurn, Staedtisches Museum

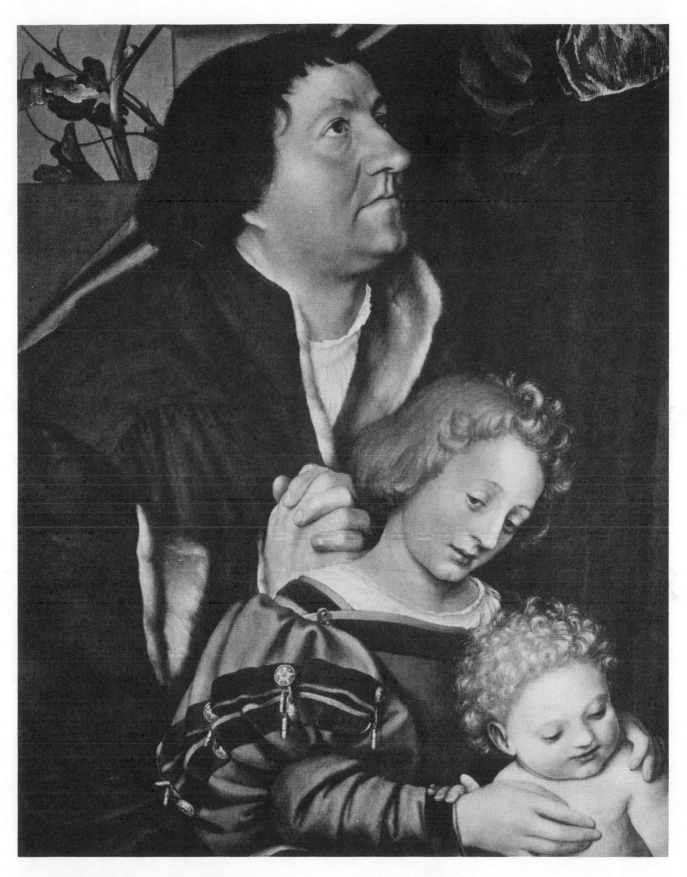

95 **HANS HOLBEIN THE YOUNGER**
 The Virgin with the family of Burgomaster Meyer
 (Detail)
 Darmstadt, Grossherzogliches Schloss

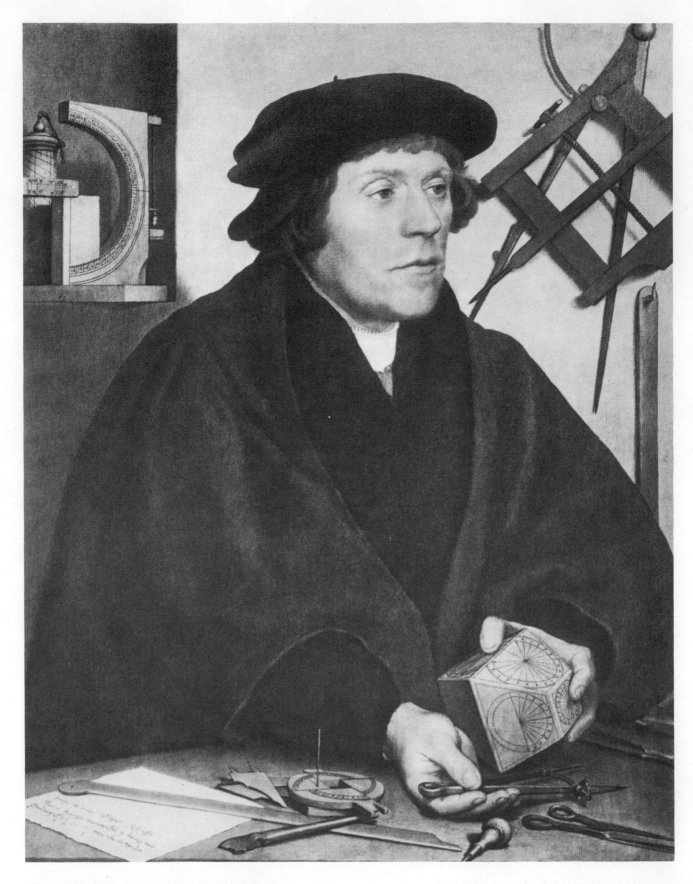

96 **HANS HOLBEIN THE YOUNGER**
 Portrait of the Astronomer Nikolaus Kratzer
 Paris, Louvre

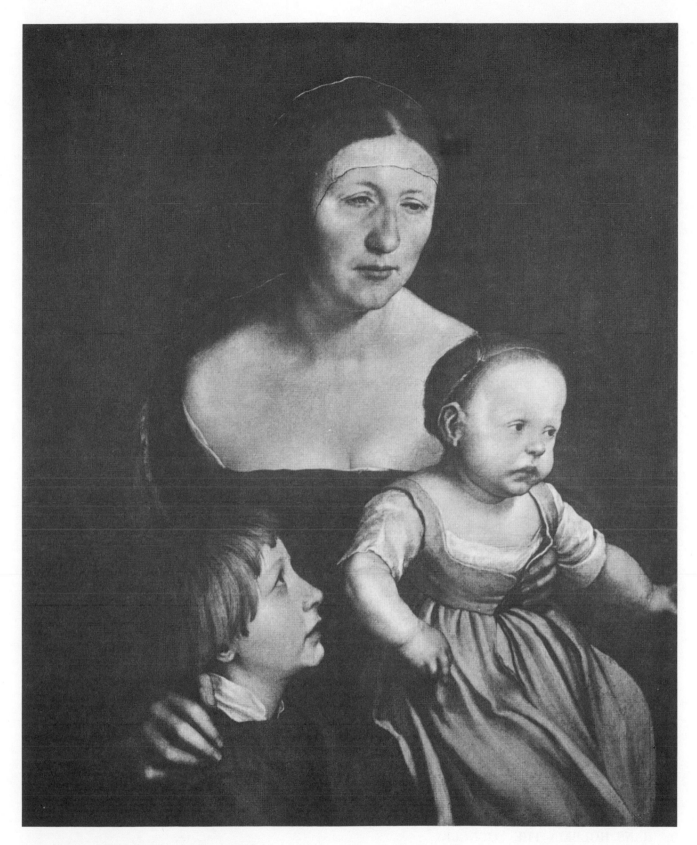

97 HANS HOLBEIN THE YOUNGER
The Wife and Children of the Artist
Basle, Oeffentliche Kunstsammlung

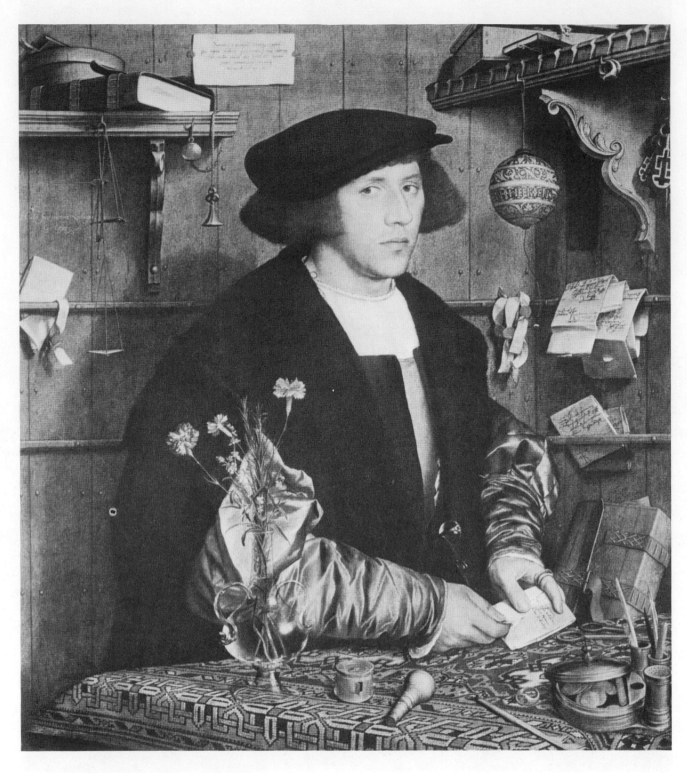

98 HANS HOLBEIN THE YOUNGER
Portrait of Georg Gisze
Berlin, Deutsches Museum

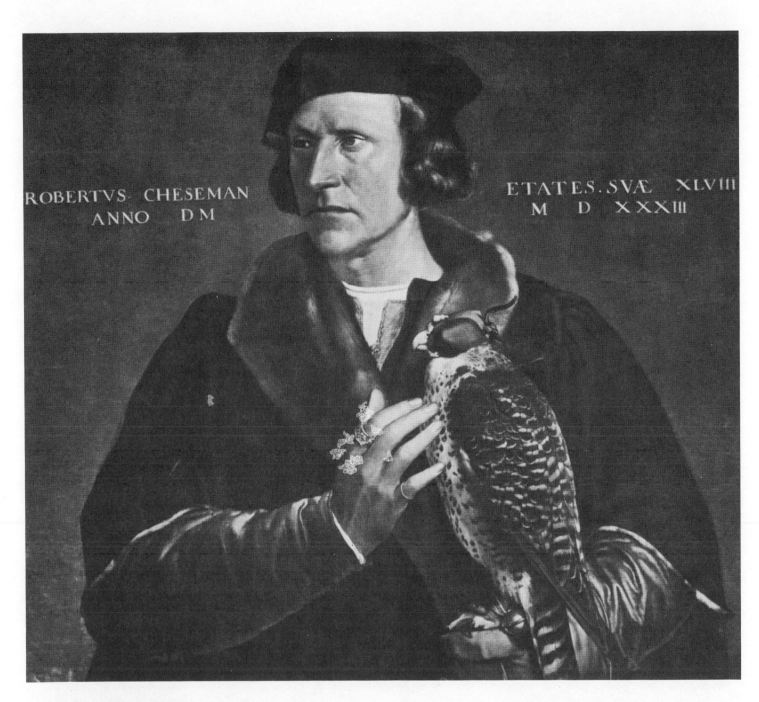

99 **HANS HOLBEIN THE YOUNGER**

Portrait of Robert Cheeseman
The Hague, Mauritshuis

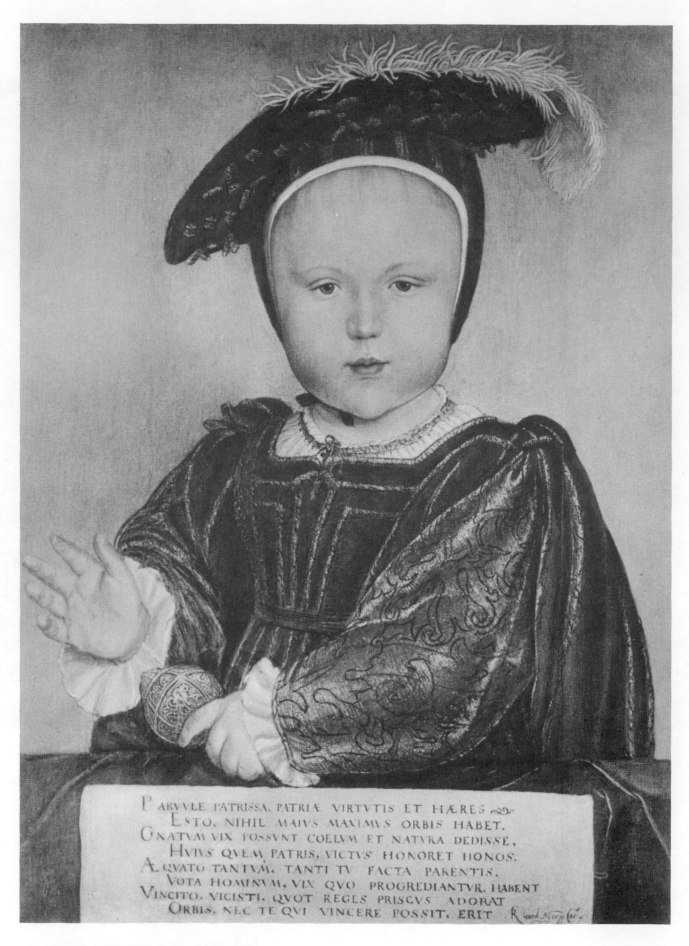

100 HANS HOLBEIN THE YOUNGER

Portrait of King Edward VI as a child
Washington, Coll. A. W. Mellon

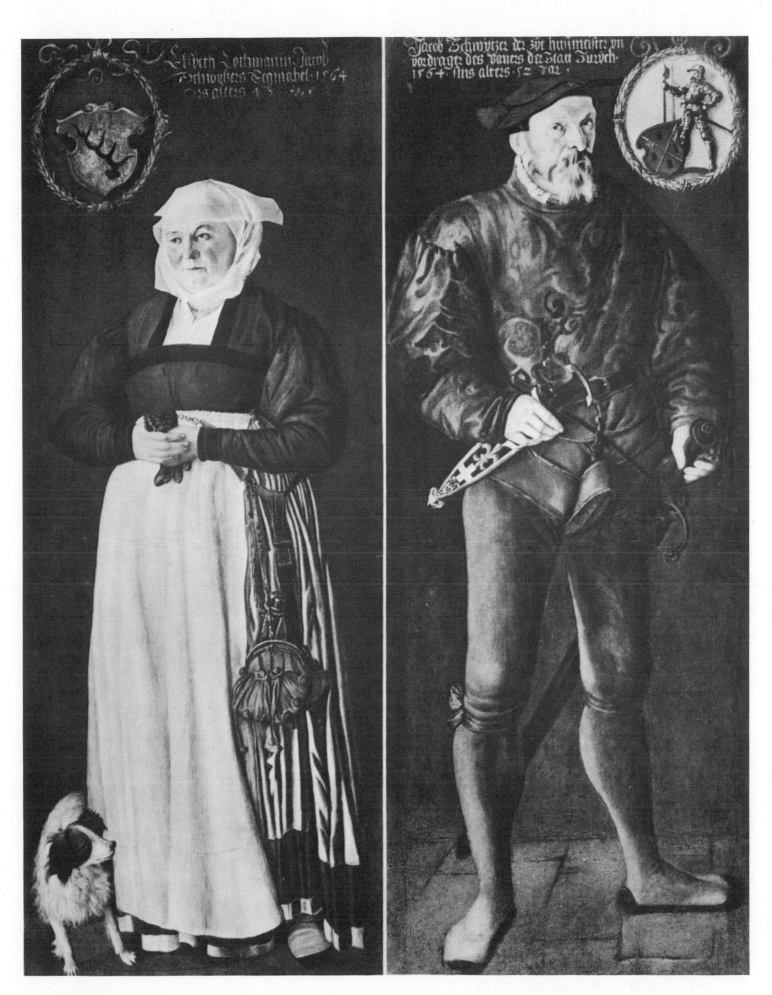

101 TOBIAS STIMMER

Portraits of Jakob Schwytzer and his wife
Basle, Oeffentliche Kunstsammlung

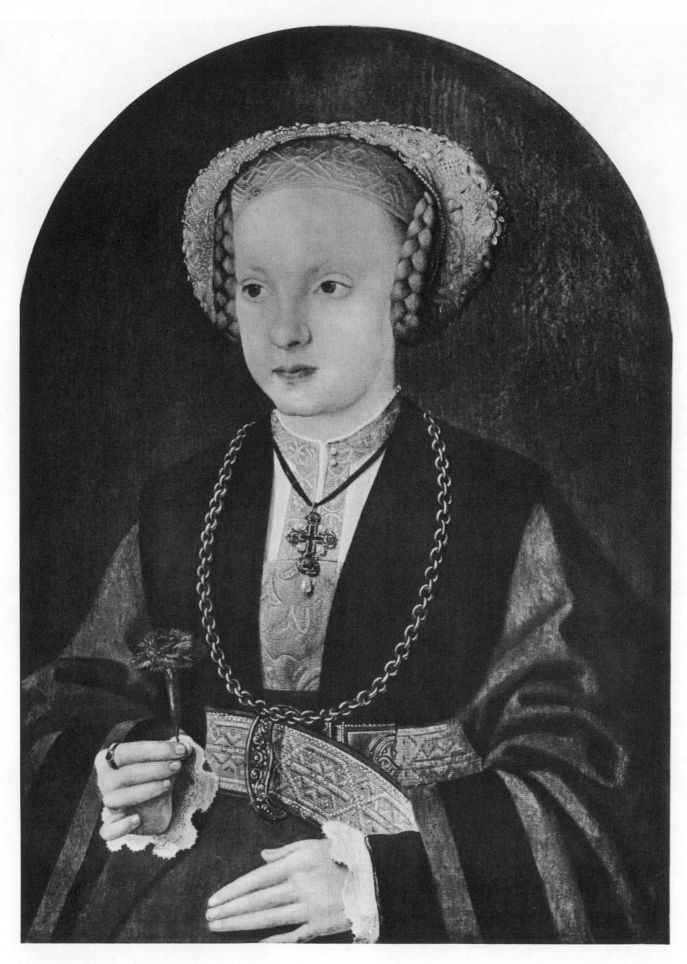

102 **BARTHOLOMAEUS BRUYN THE ELDER**

Portrait of a Girl
Munich, Julius Boehler

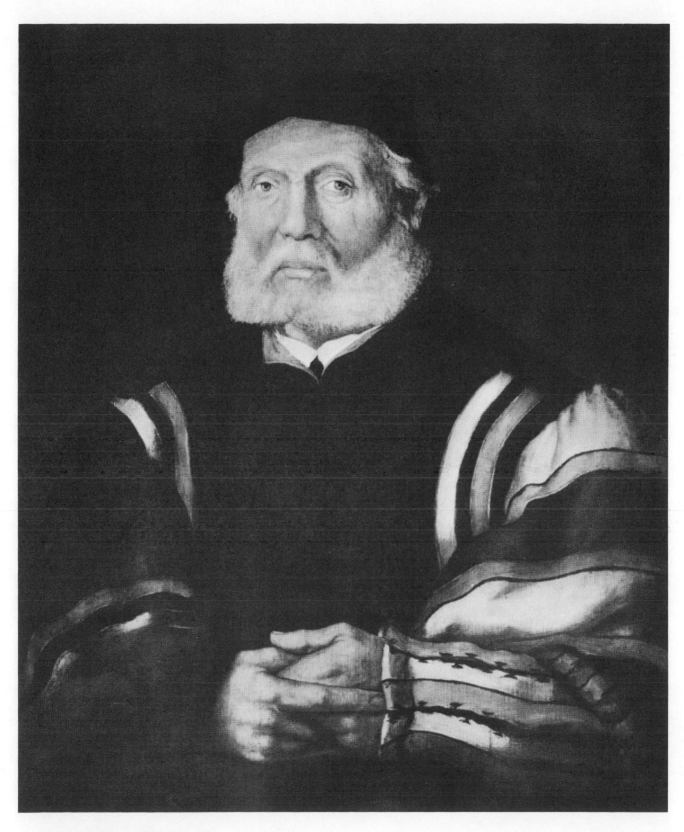

103 HEINRICH ALDEGREVER

Portrait of a man
Bremen, Roselius-Haus

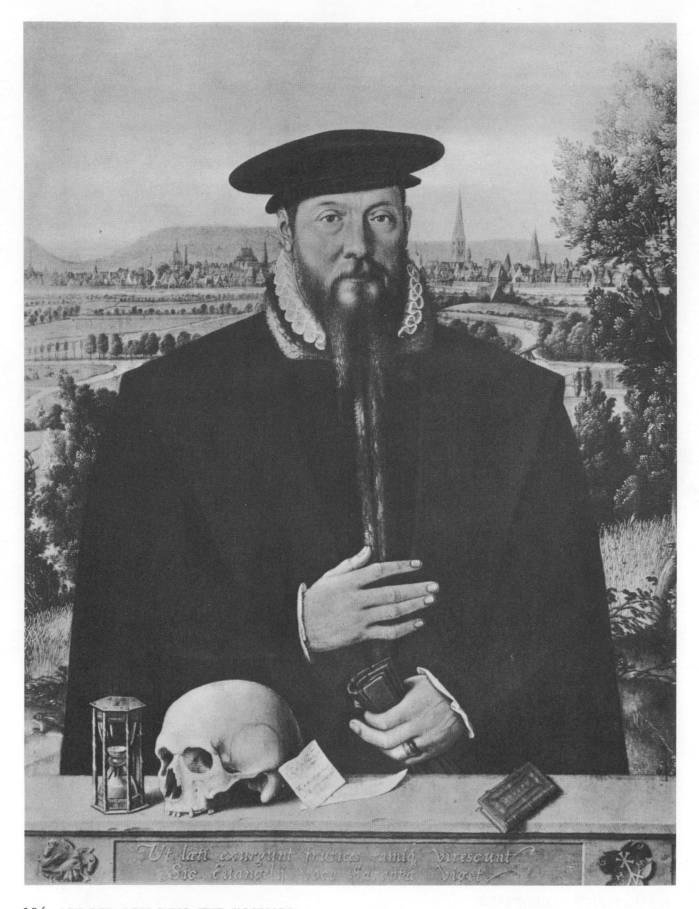

104 LUDGER TOM RING THE YOUNGER

Portrait of the priest Huddaeus of Minden
Muenster, Landesmuseum